Art Nouveau
Masterpieces of Art

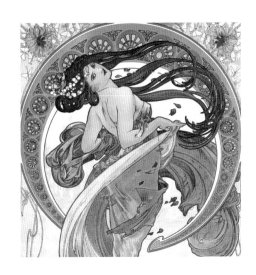

Publisher and Creative Director: Nick Wells
Commissioning Editor: Polly Prior
Senior Project Editors: Catherine Taylor and Laura Bulbeck
Art Director and Layout Design: Mike Spender
Copy Editor: Ramona Lamport
Proofreader: Dawn Laker
Indexer: Helen Snaith

FLAME TREE PUBLISHING
6 Melbray Mews
Fulham, London SW6 3NS
United Kingdom

www.flametreepublishing.com

First published 2018

18 20 22 21 19
1 3 5 7 9 10 8 6 4 2

The Art of the New images: Courtesy **Getty Images** and: Paul Almasy/Corbis/VCG: Hector Guimard, Entry to Porte Dauphine, Paris Métro (1899–1900): 7; Imagno: Koloman Moser, Vienna Secession 13th Exhibition poster (1902): 13. **Wikimedia Commons** and: Arco Ardon/CC BY 2.0: Victor Horta, Hôtel Tassel, Brussels (1893–94): 14; Steve Cadman/CC BY-SA 2.0: Victor Horta, Horta's House and Studio, Brussels (1898–1901): 20; Martin Abegglen/CC BY-SA 2.0: Antoni Gaudí, Casa Milà, Barcelona (1906–12): 21; Beyond My Ken/CC BY-SA 4.0: Louis Sullivan, Sullivan Center, Chicago (1899–1904): 22; © Jorge Royan/http:// www.royan.com.ar/CC BY-SA 3.0: Joseph Maria Olbrich, Secession Building, Vienna (1897–98): 23; Jean-Pol GRANDMONT/ CC BY 2.5: Josef Hoffmann, Stoclet Palace, Brussels (1905–11): 24. **The Metropolitan Museum of Art, New York**: Emile Gallé, Autumn Crocus' Vase (*c*. 1900): 8; Charles Rennie Mackintosh, Washstand for the Blue Bedroom in Hous'hill, Glasgow (1904): 10; René Lalique, Pendant (*c*. 1901): 16t; Lucien Gaillard, Moth pendant (*c*. 1900): 16b; Louis Majorelle, Vase (1901): 19.

Plates section images: Courtesy **akg-images**: 30, 84, 88, 94; and Erich Lessing 96; **Bridgeman Images** (and location as stated on individual pages): 11 & 57, 17 & 63, 43, 90, 26 & 93, 28 & 36, 32, 45, 46, 56, 61, 67, 80, 85, 86, 103, 108, 119; and: Mucha Trust 1 & 97; © Ackermann Kunstverlag 4 & 78, 71; Bequest of Grenville L. Winthrop 9 & 109; De Agostini Picture Library/G. Dagli Orti 12 & 91, 79, 87; © Christie's Images 15 & 116, 52 & 74, 54, 120; Granger 27 & 55; The Modernism Collection, gift of Norwest Bank Minnesota 31; De Agostini Picture Library 38 , 98, 110, 121; Artothek 48; Godong/UIG 50; Index 58; © DACS 2018/ Photo © Kunstgewerbe Museum, Zurich, Switzerland 59; Foundation for the Arts Collection 60; Gift of Azita Bina-Seibel and Elmar W Seibel 62; The Stapleton Collection 65 , 70, 95; Agra Art, Warsaw, Poland 68; © DACS 2018/ Photo © Christie's Images 73; © Leemage 89; © Estate of Galileo Chini/Photo © De Agostini Picture Library/Bardazzi 99 , 105; Mondadori Portfolio/Electa/ Enzo Brai 100; Archives Charmet 102; © Estate of William H. Bradley/Photo © Leonard A. Lauder Collection of American Posters, Gift of Leonard A. Lauder, 1984 111; © Estate of Frank Brangwyn 112; De Agostini Picture Library/M. Carrieri 113; © CCI 115; © The Fine Art Society, London, UK 118; Brown Foundation Accessions Endowment Fund 122. **Getty Images** and: Fine Art Images/ Heritage Images 3 & 35, 6 & 75, 81; Imagno/Hulton Archive 39, 42; The Print Collector 41; SuperStock 76; Culture Club 82 & 101; Leemage/Corbis 92 & 128; DEA PICTURE LIBRARY/DeAgostini 104. INTERFOTO/Pulfer/**Mary Evans** 34. Kharbine-Tapabor/ **REX/Shutterstock**: 66, 77. **SuperStock** and: A. Burkatovski/Fine Art Images 18 & 51; Artepics/age footstock 106 & 125. **The Metropolitan Museum of Art, New York**: 25 & 124, 64, 72, 114. **TopFoto** and: Imagno/Austrian Archives 37; © Estate of Josef Hoffman / IMAGNO/Austrian Archives 44; Fine Art Images/HIP 47. Kilom691/public domain/**Wikimedia Commons**: 33.

ISBN 978-1-78664-784-9

Printed in China | Created, Developed & Produced in the United Kingdom

Art Nouveau
Masterpieces of Art

Julian Beecroft

FLAME TREE
PUBLISHING

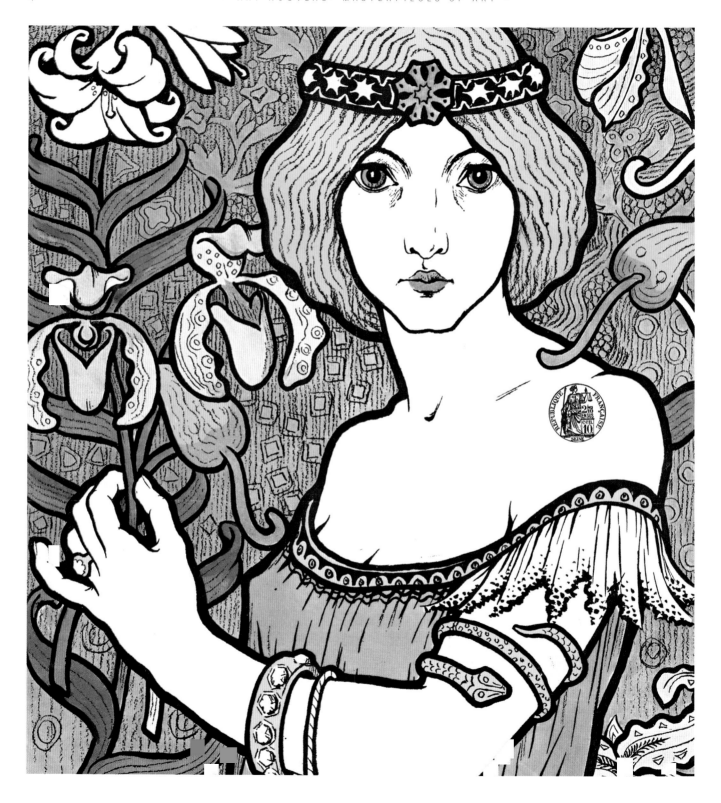

Contents

Art Nouveau:
The Art of the New

Art Nouveau is a style so diverse that even during the brief period in which it flowered, from roughly 1890 to 1914, it acquired countless different names in all the various languages of the European countries in which it had taken root. However, the one name which has come to encapsulate what, in fact, was a movement as much as a style, is the one that best describes the impact it had at the time and the radical approach to art and design it ushered in.

Culture Shock

For the century after the cultural and political shock of the French Revolution, both fine and applied decorative European art had looked to the past for inspiration. Even as the Industrial Revolution had delivered other kinds of shock to traditional ways of life – first in England, then Belgium, France, Germany, Italy, Austria and other European nations – architects, along with makers in the decorative arts, had recycled centuries of aesthetic history through new styles of art and design that were somehow reassuringly familiar. In England, the Gothic Revival and the Neo-Medieval were adopted as the Victorian house style, while Neoclassical, Neo-Renaissance, Neo-Baroque and even Neo-Rococo styles were the basis of waves of artistic pastiche that ebbed and flowed through nineteenth-century European visual culture.

In turning away from historicism, from the prevailing retro fashions of the late-nineteenth century, Art Nouveau represented a paradigm shift in art history, one of those rare moments when the artistic perception of a whole civilization begins to make a decisive and irrevocable change. With Art Nouveau, that change was the dawning of the modern world, for which a new kind of art was needed in which any links with the past were not automatic but the result of self-conscious

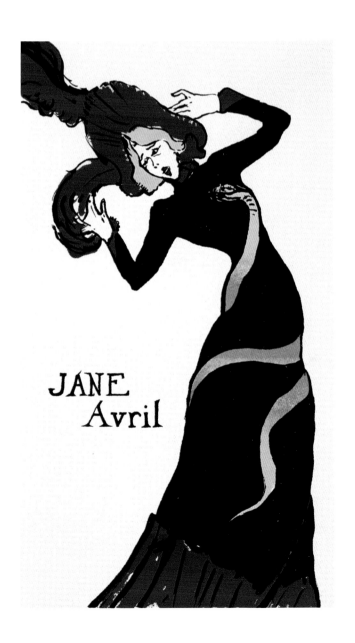

selection from a range of options of which historical tradition was only one. At the same time, an increasingly affluent urban bourgeoisie with a growing interest in the arts placed less importance on a cultural past that had served an aristocratic elite in which their own families had not been included. They were ready for something new that reflected both the world they lived in and the one they sensed was coming.

Total Art

Of course, the new style had to come from somewhere, and in searching for the many sources of Art Nouveau we need to consider attitudes to the making of art as much as individual traditions or phenomena that were an influence on the new style. For one thing, Art Nouveau artists and makers were inspired by the idea of the total artwork – the *Gesamtkunstwerk* embodied in the titanic music dramas of Richard Wagner (1813–83), which cast a long shadow over late-nineteenth-century European culture as a whole. In the plastic arts, this manifested as a new desire to create interiors in which everything – all the elements in a room – adhered to a central governing aesthetic, an ambition that contrasted with the piecemeal eclecticism that had become the common look of most Victorian drawing rooms.

Another motivating force, arising from the Arts and Crafts Movement that thrived in England throughout the 1880s, was a resistance to the methods of mass production then beginning to shape the aesthetic tastes of a growing urban middle class through works of decorative art that were badly designed and poorly made. At a time when the division of labour at the heart of the modern industrial model was alienating more and more people from their work and wider environment, the critic John Ruskin (1819–1900) and the designer William Morris (1834–96), influenced by Karl Marx (1818–83), promoted the socialist utopian idea, inspired by notions about the Middle Ages, of a handmade art in which the ordinary artisan would regain control of the means of production. Doing so, it was hoped, would empower them to create well-made works of great spiritual integrity which had sprung from their sovereign imagination as well as from their own hand. A romantic idea, it set up a tension that became central to the appeal of Art Nouveau, where what appears spontaneous and handmade – such as the curved wrought ironwork

of the designs of Hector Guimard (1867–1942) at the entrances to stations of the Paris Métro, or the curlicue iron staircases of Victor Horta (1861–1947) – quite often could only have been fashioned by means of an advanced industrial process; indeed, the commercial success of the style in the 1900s could only have come about through mass-production methods, even if the surge in popularity of Art Nouveau at the dawn of the new century sowed the seeds of its equally rapid demise.

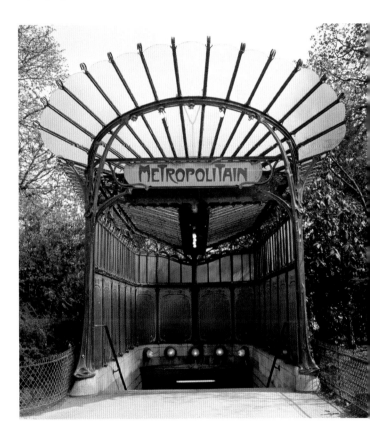

A Clearing of Art

For hundreds of years, the fine arts of painting and sculpture had enjoyed an elevated status, with the decorative arts of furniture, glass, ceramics, etc., regarded as somehow inferior – aesthetically compromised on account of the utilitarian nature of the object itself. With the Arts and Crafts Movement, this began to change, so that one of its leading members, the English artist and book illustrator Walter

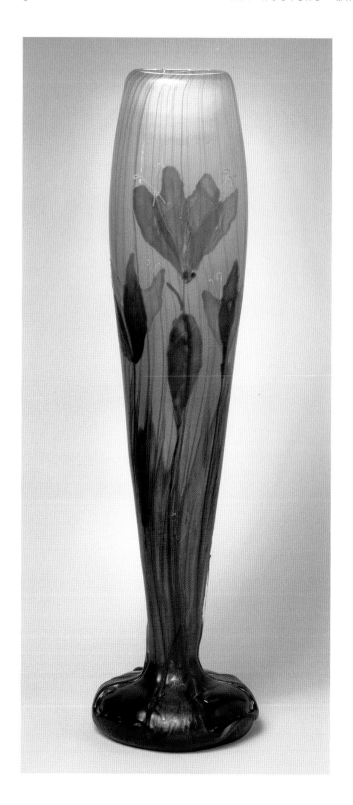

Crane (1845–1915), could write in the 1880s of turning 'our artists into craftsmen and our craftsmen into artists'. The Belgian designer Henry van de Velde (1863–1957), among the most important thinkers as well as makers in the new style, visited England as a young painter and was inspired by Arts and Crafts ideals. He later wrote what became an unofficial manifesto for Art Nouveau, a pamphlet entitled *Déblaiment d'Art* (1894, literally a 'clearing of art'), which made a philosophical case for parity of esteem among all the arts, both fine and applied. It was this atmosphere of openness and radical reassessment that led to the revival of what in some cases were moribund traditions of decorative art; this development has continued to emphasize the importance of design across the entire field of applied art right down to our own day.

If the ideals of the Arts and Crafts Movement provided a template for a new art, some of its artefacts – such as the botanical wallpapers of Morris or the magnificent 1882 chair by Arthur Heygate Mackmurdo (1851–1942), with its asymmetrical fretted back of swirling plants – offered up perhaps the single biggest source of inspiration for the new style. Leading designers of Art Nouveau such as Émile Gallé (1846–1904) and Hermann Obrist (1862–1927) had been trained as botanists. In the 1890s they turned to nature as a source of inspiration, an Arcadian influence that simultaneously enabled them to break from any reference to the aesthetic past and to forget the deadening industrial present.

Nature as Refuge

To be modern means to be urban, and Art Nouveau appeared at a time when the greater part of populations in those countries where the style flourished began to live in large towns and cities. For the first time in history, the majority of modern men and women experienced nature not as an environment with which to do battle and to overcome, but as an amenity provided by the state or city council as a means of relaxation and leisure, an oasis in the desert of industrial modernity.

Recognizing an implicit social need, Art Nouveau artists and designers took nature in one form or another as their principal theme, even if only a small proportion of the urban populace could afford their wares. In the city of Nancy in eastern France, Émile Gallé, the trained botanist,

developed a method of relief carving and etching into thick glass, which he used to decorate his vases with botanically accurate and naturalistically rendered plant forms. Louis Majorelle (1859–1926), another member of the École de Nancy, as the group of designers based in the city was known, embellished his furniture with inlays using natural motifs such as water lilies, plant stems and dragonflies. And in the Catalan city of Barcelona in northern Spain, the architect Antoní Gaudí (1852–1926), an exponent of the Modernisme style – the Catalan variant of Art Nouveau (*Modernismo* in Castilian Spanish) – took nature as direct inspiration for extraordinary buildings like the unprecedented Casa Batlló (1904–06). A multistorey townhouse, its blue-tiled roof evokes fish scales, while the fluid, tiled mosaic façade suggests a submarine world from which sculpted balconies resembling skeletal piscine heads project ghoulishly into the street.

Gauguin's Line

It was also nature in stylized form that provided the sinuous curving line so typical of Art Nouveau. Indeed, such unity as exists across all the diverse manifestations of the style stems primarily from the governing principle of line. We see it in the black and white illustrations of Aubrey Beardsley (1872–98) in the mid-1890s; influenced by the literary decadence of Oscar Wilde and the Aesthetic Movement, these images are conventionally regarded as the first evidence of the new linear Art Nouveau style. It is there, too, in the ripe sensuality of the work of Paris-based Czech poster artist Alphonse Mucha (1860–1939), and it is also present in the more austere curves of the Scottish architect and designer Charles Rennie Mackintosh (1868–1928) and the Glasgow School. It is even present in the more geometric designs of Josef Hoffmann (1870–1956) from the slightly later Austrian Secession movement, regarded as the last significant iteration of the style.

This line was taken not only from nature but also from painting. Many of the leading Art Nouveau practitioners began life as painters in the 1880s and were strongly influenced by the Cloissonist painting that Paul Gauguin (1848–1903) and Émile Bernard (1868–1941) developed at Pont-Aven in Brittany towards the end of that decade, with its strong emphasis on clear outlines and areas of flat colour to define form, an effect similar to stained glass or indeed to the cloisonné enamel

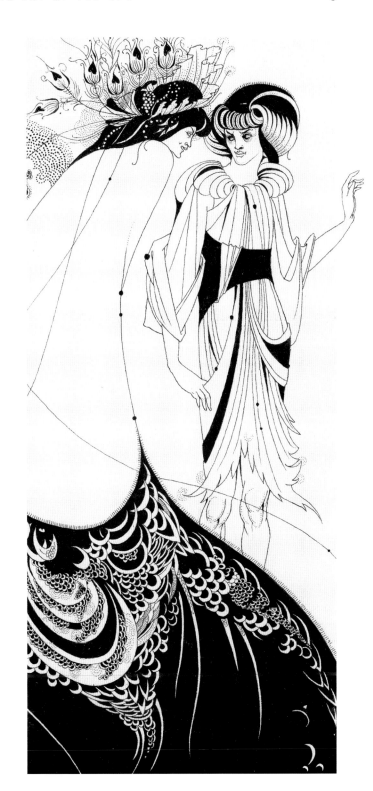

decoration of metalwork from which that style of painting took its name. Many of the followers of Gauguin, in a group called Les Nabis (The Prophets) which included painters such as Maurice Denis (1870–1943) and Paul Ranson (1864–1909), took these discoveries and applied them to images that were quite obviously decorative and identifiably Art Nouveau.

Maison de l'Art Nouveau

In fact, the work of these painters, along with other members of Les Nabis, as well as leading figures in the decorative arts, began to reach a wider public through the Maison de l'Art Nouveau, the Paris shop opened in December 1895 by Siegfried Bing (1838–1905), which gave the style its name. A generation earlier, Bing, a German art dealer, had helped introduce Japanese art to the West. The new shop was instrumental in disseminating the total phenomenon of Art Nouveau, commissioning numerous works not only from members of Les Nabis (in their case, as tapestries, stained glass or prints), but also from designers working in the decorative arts, such as glassmaker Émile Gallé, interior designer Georges de Feure (1868–1943) and jeweller René Lalique (1860–1945). Ever resourceful, the great entrepreneur also took Art Nouveau across the Atlantic to a massive new market in the USA, particularly on the east coast. At the same time, he brought the work of glass designer Louis Comfort Tiffany (1848–1933) to Europe, where America's greatest Art Nouveau artist enjoyed great success.

The other key promoter of the new style from the mid-1890s was Arthur Lasenby Liberty (1843–1917). The owner of what was then London's leading department store, which had opened in 1874, Liberty commissioned pieces from leading British designers, principally Archibald Knox (1864–1933), whose work was closest to Art Nouveau among his English peers. Liberty had also been an early supporter of the Arts and Crafts Movement and, like Bing, was a keen enthusiast of Japanese art. In fact, the art of Japan had had a huge influence on all the arts since the 1860s, when prints by Katsushika Hokusai (1760–1849), Utagawa Hiroshige (1797–1858) and others had first appeared in world's fairs in London and Paris. The Impressionists were early adopters of techniques employed by Japanese artists, as was Gauguin after them. The Japanese influence is also clear among Art Nouveau artists in the austere furniture of Charles Rennie Mackintosh, for example, or the sinuous graphic line and the stark use of contrast in the work of Aubrey Beardsley, or the asymmetrical, cut-off poster images of the painter Henri de Toulouse-Lautrec (1864–1901).

Ancient Sources

Post-Impressionist painters such as Gauguin had also adopted the asymmetry of Japanese art, as well as its simplified approach to colour and form, and its relative indifference to ideas of perspective which had governed Western art for centuries. Line and colour, and thus the decorative surface of an image, were paramount – priorities that became central to Art Nouveau. Other forms of strongly decorative and non-narrative art – Islamic and Byzantine art, for instance, and Celtic

art in the case of the Glasgow School – also exerted varying influence on different artists working within the style. Indeed, the greatest painter associated with Art Nouveau, the Austrian Gustav Klimt (1862–1918), combined the mythology of the Old Testament and the Classical world with a sumptuous decoration using gold leaf – redolent of the long tradition of icon painting and gilded mosaics in the Byzantine Church – as well as an ornate decorative style learned from non-European traditions, including those from the eastern Mediterranean and North Africa, to evoke an atmosphere both devotional and transgressive in paintings such as *Judith* (1901, *see* page 45).

Images such as this one owed much to the Symbolist art which had become prominent in European painting during the 1880s. Symbolism was another broad-based movement, where the manifest subject of a painting contains another, symbolic level of meaning, either more or less obvious. Symbolist painters such as Gauguin, the Swiss artist Arnold Böcklin (1827–1901) and the Belgian Fernand Khnoppf (1858–1921) frequently borrowed from myths and legends to address metaphysical questions.

Poster Art

Art Nouveau took from Symbolist art a penchant for myth and fantasy which, though often reduced to a purely decorative function, was still a key characteristic of the new style. Exotic non-Western art, myths and ancient legends, and a wide variety of natural forms and sensual feminine figures were all transformed into decorative visions or environments offering aesthetic escape from what was felt to be the oppressive rationalism of late-nineteenth-century life. Gauguin's own development of a decorative Symbolist art and his antipathy towards conventional perception led him in the 1890s to flee a 'civilized' Europe he could not abide; many Art Nouveau artists, on the other hand, actively celebrated the modern world and its pleasures through their art. Liberated from old modes of representation, graphic artists such as Jules Chéret (1836–1932) and Toulouse-Lautrec – the latter a considerable Post-Impressionist painter himself – developed a wholly new art form which became synonymous with Parisian Art Nouveau: the illustrated advertising poster, enabled by Chéret's own three-stone lithographic process.

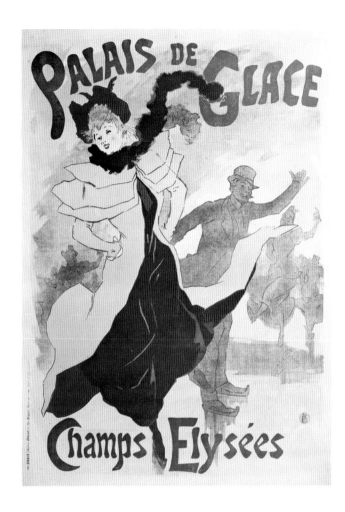

Being an ephemeral form pasted on the walls of the city's buildings, often in groups of repeated images wherever there was space, it is perhaps surprising how many of these bright and bold impressions of Belle Époque Paris have survived. However, if one of the democratizing tenets of Art Nouveau was that fine and applied art were equally worthy of esteem, then another core belief, evident in the bold poster images we do still have, was that commercial two-dimensional art had qualities that made it valuable in its own right and which informed the development of fine art thereafter. The images created in the 1890s, in particular by Post-Impressionists such as Toulouse-Lautrec and the young Pierre Bonnard (1867–1947), show a high level of artistic daring that speaks of a shift in attitudes to popular culture which is identifiably modern.

A Female Type

Another notable pioneer of the illustrated poster was the Franco-Swiss artist Eugène Grasset (1845–1917), whose mostly decorous images of pensive young women in stylized natural settings became popular not only in Europe but, through magazine illustrations, in the United States as well. However, probably the most celebrated of all the poster artists was Alphonse Mucha, whose association with the actress Sarah Bernhardt (1844–1923) and the Théâtre de le Renaissance in Paris led to some of the most voluptuous images of the period. Mucha's posters were created in the 1890s, some years before universal suffrage took root in the Western Hemisphere, and the seductive young women who feature in them are not so much empowered as coquettish and carefree, their loosely worn light dresses an invigorating contrast to the corseted drapery that characterized women's fashions in the late Victorian era, even in Paris. Even now (and certainly then), these women are fantasy females, representing a feminine ideal whose provenance lies at least in part in the statuesque female subjects of the Pre-Raphaelites, but set free by the hedonistic atmosphere of the *fin de siècle*. For some, including many French art critics as well as some of the English Arts and Crafts designers whose work had inspired the Continental leaders of Art Nouveau, the new style was decadent and trivial. For others, such as the members of a newly affluent middle class who were keen to acquire its products, it was liberating – a modern style offering freedom from the growing constraints of the modern world.

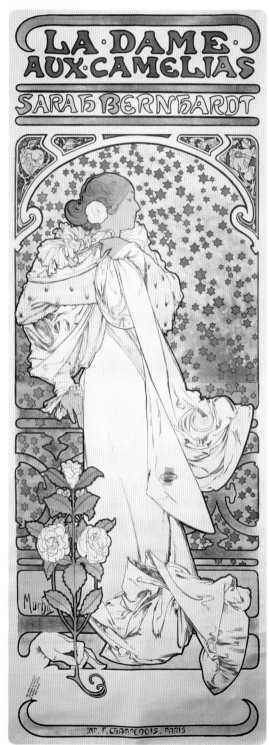

International Style

Art Nouveau was not the first international design style, but it spread more quickly than any before it. Modern methods of travel, notably the railway, made countries across the Continent, and even in North America, accessible within a very short time, with the result that artists and designers like van de Velde moved with ease from one country to another as they developed. Moreover, radical work from designers living and creating in previously obscure locations, such as Mackintosh in Scotland, quickly came to international attention by being exhibited in cultural centres like Vienna; the work of Mackintosh in particular helped to shape the developing aesthetic of the Vienna Secession around the turn of the century.

This cultural exchange was not always to the liking of the more nationalist critics – Bing's Paris shop was lambasted for not featuring enough work by French artists – but internationalism was integral to the style, just as had been the case with previous pan-European cultural phenomena such as the Baroque. Moreover, these easy connections simply reflected the increased pace of exchange, both within Europe and across the world, in what was the first global age. By the turn of the century, and beginning with the Great Exhibition in London in 1851, a large number of world expositions had already been held, with increasing frequency, on three continents and especially all over Europe. They brought design and technological innovation from across the globe, including artefacts from

the European colonies whose number had burgeoned in the final three decades of the nineteenth century, exposing artists, designers and the public who saw these great shows to a plethora of new sources of inspiration. The expos held in Brussels in 1897, Paris in 1900 and Turin in 1902 witnessed the greatest triumphs of Art Nouveau.

Magazine Culture

A slew of new periodicals promoted the style in almost every country where it came to matter. It was in one of these, the English journal *The Studio*, that Beardsley first came to public notice with an illustration in the very first issue, in April 1893 – a shocking image called *J'ai baisé ta bouche, Iokanaan* (*see* page 110), from his series for Oscar Wilde's published play *Salome* (1893). The previous year had seen the founding of the Munich Secession, the first of several such independent artistic organizations to arise in the German-speaking countries in the 1890s; 1896 saw the first appearance of the group's official publication, the illustrated journal *Jugend* (Youth), perhaps the most important of all magazines promoting the new style, from which Jugendstil, the German manifestation of Art Nouveau, got its name. In 1895, the Berlin journal *Pan* had been co-founded by the German critic Julius Meier-Graefe (1867–1935), who went on to start up yet another influential magazine, *Dekorative Kunst*, in 1897, followed shortly afterwards by the opening of his own gallery in Paris, La Maison Moderne. In 1897, *Ver Sacrum*, the official magazine of the Vienna Secession, was first published, while in the same year

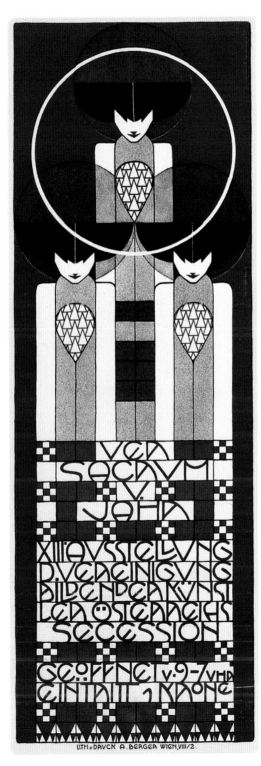

LITH.v DAVCK A.BERGER WIEN,VIII/2.

in Darmstadt in western Germany, another very influential journal, *Deutsche Kunst und Dekoration*, was launched.

Workshop Culture

These periodicals gave opportunities to painters and printmakers to publish a new kind of work that was shaped by the medium. In Germany, they helped establish the aesthetic that was then applied to the practice of architecture, furniture and interior design through the Vereinigte Werkstätten für Kunst im Handwerk, established in 1898 in Munich and in the northern German city of Bremen; its members included leading Jugendstil designers such as Richard Riemerschmid (1868–1957), Bernhard Pankok (1872–1943), Hermann Obrist and Bruno Paul (1874–1968). A few years later, in 1903, across the border in the Austrian capital, the still more successful Wiener Werkstätte was set up by architect Josef Hoffmann and graphic artist Koloman Moser (1868–1918). It was soon employing 100 craftsmen to produce items including furniture, glass, ceramics, jewellery, fashion, tableware and silverware, designed mostly by its two founding spirits. Moser's designs for applied art aside, his posters for some of the many exhibitions held by the Wiener Secession during its great period – between its inception in 1898 and the First World War – are classics of the austere Secession style, rivalling posters for other exhibitions in the same sequence by Alfred Roller (1864–1935) and Klimt. A comparison of these distinctive rectilinear images with the fluid poster art of Art Nouveau in Paris gives a clear idea of how much variety there was among groups of practitioners across Europe ostensibly working in the same style.

The Line of Beauty

At this point, it is worth considering the fundamental elements that allow us to speak of such a wide range of styles being part of the same collective movement. One of these, the primacy of line, has already been mentioned, its sources identified in various quarters, from a stylized nature to the dominance of line in Japanese art. The most elastic form in which the Art Nouveau line appeared was probably Obrist's *Cyclamen* embroidery from 1895, known as the 'Whiplash' embroidery; this, like the decadent illustrations of Beardsley, established a linear rhythm for the new art which emerged contemporaneously in the exuberant ironwork of Victor Horta's Hôtel Tassel (completed in 1893 and considered the first genuine Art Nouveau building) or his Hôtel Solvay the following year, both in Brussels. These great buildings

in turn inspired Hector Guimard in his designs for the ironwork of the Castel Béranger (1894–98) in Paris and the entrances to 141 of the city's Métro stations (1900). In the misshapen anatomies of Aubrey Beardsley's amoral, etiolated figures, the pliable curving line that structures his drawings appears grotesque, an impression exacerbated by the subject matter. However, in French and Belgian Art Nouveau, the line, although just as stylized in the ironwork of Horta or the poster art of Mucha, gives the impression of having been copied straight from a nature in rude and fecund health. In contrast to Beardsley's elegant caricatures, Mucha's seductive women are proportioned according to a classical ideal, framed by swirling skirts and their own absurdly long tresses, set against a seemingly natural background or stylized, circular arch, as in *La Dame aux Camélias* (1896, see page 91) and *The Arts: Dance* (1898, *see* page 97).

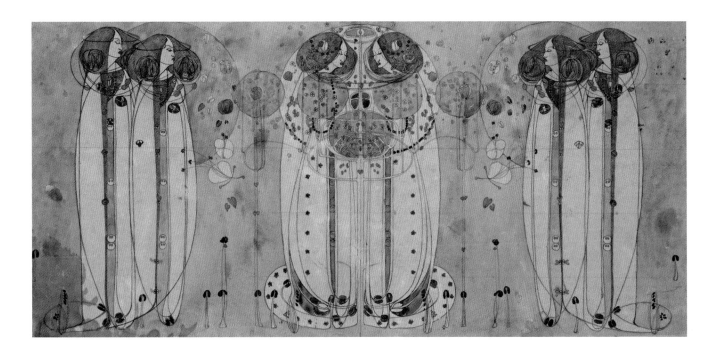

A Scots Original

In the work of Charles Rennie Mackintosh and his colleagues in the Glasgow School, on the other hand, the characteristic curving line is neither exuberant nor exotic but austere and attenuated, extending in a shallow arc before turning tightly on itself, often into a closed knot or the 'rose ball' ornament unique to their work; or otherwise, in the case of his furniture, strictly geometrical. Mackintosh, his wife Margaret MacDonald Mackintosh (1864–1933), her sister Frances MacDonald (1873–1921) and Frances's husband Herbert MacNair (1868–1955) developed this noble, curvilinear rhythm and grammar of ornament in part from their knowledge of Celtic art, with its patterned decorative knotting. Like the Manxman Archibald Knox, the Glasgow Four drew on their country's Celtic heritage to provide a distinctive visual language with a spiritual dignity rooted in a sense of place and intuited history. The overall effect is ceremonial, as in medieval art. Indeed, their work, like so much of the Modernism that would follow, appears to draw sustenance from a time before, or simply outside, the revolution in perception that occurred in the Renaissance, whose tradition of faithful representation, having ossified into academic cliché, was increasingly irrelevant to modern artists seeking a new vision of the human in an increasingly dehumanizing age.

Continental Influence

In the architectural interiors Mackintosh undertook, such as those of the various Glasgow tearooms he designed around the turn of the century, he also made much greater use of mirror symmetry (inherent in nature) than his French and Belgian counterparts; it's a quality evident in mural decorations such as *The Wassail* (1900, *see* above and page 116) that he and Margaret executed for these rooms as well as the exhibition posters he and other members of the Glasgow School designed to promote the city's cultural events and institutions. The originality of Mackintosh's vision was such that it was soon exerting a huge influence on the development of Continental Art Nouveau. The room he designed for the 8th exhibition of the Vienna Secession, held in November and December 1900, caused such a sensation that Viennese designers were drawn to a wholly new aesthetic – a restrained and ultimately geometric language, emphasizing verticals. This is evident in the Secession exhibition posters produced after the show in which Mackintosh was involved, such as those of Moser and Roller, which adopt the same rectilinear format favoured by the Glasgow School.

Style and Simplicity

The emphasis on line enabled not only a stylizing of nature or the human figure, but also a graphic simplification that was easily transferrable across a range of disciplines in the fine and applied arts, thus lending a tangible unity to the vast range of three-dimensional objects and two-dimensional images produced within the style. In two-dimensional works, while the importance of perspectival representation was diminished after Gauguin – with a greater emphasis on line, colour and surface – any stylization might also be dictated by the medium in which it was rendered, such as embroidery, as with van de Velde's Nabis-like appliquéd wall-hanging *La Veillée des Anges* (1893, *see* page 59) or the elegant *Dame en robe rouge* (1898, *see* page 96) by József Rippl-Rónai (1861–1927). Equally, the medium might warrant simplicity for other reasons, for instance, in the case of tapestry, by way of imitating the simplified styles of folk art, a key influence on Scandinavian 'National Romantic' Art Nouveau, as in the tapestry *Tre prinsesser Eventyrhaven* (*Three Princesses in the Fairytale Garden*, 1892, *see* page 84) by Norwegian artist Gerhard Munthe (1849–1929).

Two-dimensional Art Nouveau, such as the illustrated poster, the tapestry or the print, often involved a design that was clearer and simpler than previous styles. However, in three-dimensional mediums the emphasis on organic, curving forms often took design in the direction of greater structural or decorative complexity. This presented a technical challenge which advances in technology were not only able to address, but in fact encouraged designers to see how far they could push industrial ingenuity in the service of a sophisticated decorative vision, as we have seen with the elaborate wrought ironwork of Horta or Guimard.

Old Arts Renewed

In furniture design, the new vision and the flexibility of woods such as ash gave free rein to the likes of Eugène Gaillard (1862–1933), Louis Majorelle and especially the Belgian Gustave Serrurier-Bovy (1858–1910) to fashion structurally elaborate pieces that seemed almost to have grown like living organisms into their finished forms, rather than having been made that way. Similarly, new techniques such as acid etching and wheel engraving developed by glassmakers like Gallé and the Daum Brothers – Auguste (1853–1909) and Antonin (1864–1931) – in the city of Nancy provided the means to realize bold new designs enriched by botanical life in the case of Gallé, and insect life as preferred by the Daums. In the case of jewellery, Lalique, the outstanding talent of his generation, also favoured insects as a motif, such as the extraordinary *Dragonfly Woman* brooch, a compelling hybrid creature drawn from the depths of a truly Gothic imagination, conveying a morbid misogyny typical of the period. Pioneering a new kind of jewellery, Lalique combined semi-precious stones and organic materials, such as horn and coral, with brightly coloured glass and enamel whose use in this delicate context he had refined through years of patient research.

Abstraction

The innate stylization of Art Nouveau led not only to a simplification of forms but also to the elimination of historical forms of ornament by making the ornament structural. This was particularly the case in wallpaper, textiles, and poster and fine art, where ornamental units became the basis for a larger structural pattern that was inherently decorative, as in the patterns of Moser, such as the *Scylla* design of 1901 (*see* page 42). In poster art, too, a tendency towards Modernist motivic abstraction was a logical corollary of Art Nouveau's prioritizing of line, as can be seen in van de Velde's 'Tropon' poster from 1898 (*see* page 73). But even in painting, the decorative tendency contributed to the unreality of many Art Nouveau images. In Ranson's canvas *The Two Graces* (1895, *see* right and page 63), the stylized female figures' robed nobility may owe something to the Pre-Raphaelite aesthetic, but the sense of unreality is intensified by a background which consists almost entirely of an irregular but identifiable pattern in two autumnal colours, as if the seasonal display were simply a fabric for interior furnishing that's been spread over the scene.

Klimt

This structural use of decoration and pattern was raised to its apogee in the work of Gustav Klimt. A great admirer of the Swiss painter Ferdinand Hodler (1853–1918) – himself a major figure in the various Secession movements in Germany and Austria – Klimt began in the Symbolist tradition of the 1880s. Around the turn of the century he was producing paintings such as *Pallas Athena* (1898, *see* page 36), *Judith* (1901) and especially the *Beethoven Frieze* (1902, *see* page 46) – the extraordinary fresco cycle he painted for the Secession building in Vienna – which took mythical or Classical subjects to convey a philosophical programme through allegory and symbol. In these works, there is already evidence of the extravagant gilding, evoking a long tradition of devotional art from Late Antiquity to the International Gothic style of the late medieval period, which would achieve its most sumptuous effects, using real gold leaf, in his two most famous paintings, *The Kiss* (1904–07) and the *Portrait of Adele Bloch-Bauer I* (1907, *see* page 51).

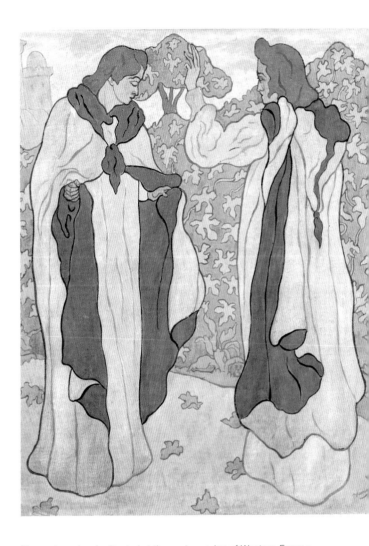

Vienna is curiously situated at the eastern edge of Western Europe and in Klimt's day was the capital of a European empire that lay all to the east, made up in part by countries which at one time had been under Ottoman rule. The influence of this distinctive historical and geographical orientation was further refined by the artist's encounter in 1903 with the Early Christian mosaics of Ravenna in northern Italy. The Byzantine opulence of these images only confirmed to Klimt the rightness of a decorative instinct which had already achieved a high level of realization in the *Beethoven Frieze*, a visual representation of the *Ninth Symphony* of Ludwig van Beethoven (1770–1827), in which an astounding variety of decorative patterns serves either as background between standing figures or as the lower raiment or hair

decoration of a semi-nude pregnant woman. In the section depicting a knight in his gilded suit of armour, the two women behind him wear garments without any clear definition other than the pattern of fabric from which each is made, as if the patterned surface has rendered their bodies flat.

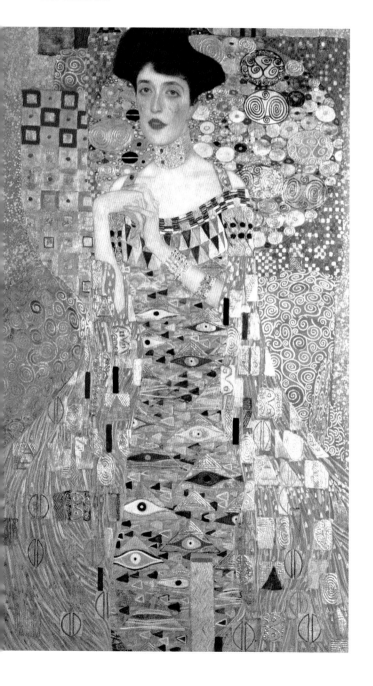

Adele Bloch-Bauer

This flattening tendency in the form of decorative ornament becomes an increasing factor in Klimt's work from then on, so that in the *Portrait of Adele Bloch-Bauer I* (*see* left), an ostensible three-dimensional depiction is distorted by the range of ornate patterns in the sitter's dress. These feature motifs such as eyes taken from ancient Egyptian art, merging with the complex mosaic background against which she poses, which is itself comprised of a panoply of ornament that seems to derive from another ancient tradition of the East. Only the realistic depiction of the woman's head and hands have not been subsumed into the maelstrom of decorative activity, their faithful representation and pale colour contrasting with the exotic background to persuade us of the painting's realistic origins, but only just. Here, the tension between fantasy and reality that is one of the chief characteristics of the best of Art Nouveau, in whichever national or regional iteration, is articulated with bewitching clarity.

Femmes Fatales

Klimt's patrons, as with those of the Wiener Werkstätte, were wealthy Viennese Jewish businessmen whose wives in some cases may have become the artist's lovers. Klimt's love of women is evident in his depictions of them, so often luxuriating in a sensual paradise of decorative excess. This celebration of women in general and the female form in particular is a common theme of much Art Nouveau, especially in poster art: from the hedonistic Parisiennes of the posters of Chéret and Mucha to more genteel images by Paul Berthon (1872–1909), Maurice Pillard Verneuil (1869–1942) and the Belgian artist Henri Privat-Livemont (1861–1936). Posters were commercial messages, after all, and female beauty sells. However, we have already seen how the sinuous line of the female shape was an abstract structural principle in the femmes fatales of Beardsley, and indeed it is not hard to see echoes of sensual female forms in the curvilinear bias of so much Art Nouveau furniture or ironwork or even the floral lamps of Louis Majorelle. These echoes were even more explicit in the famous Peacock Lamp (*c.* 1901) of Belgian jeweller and sculptor Philippe Wolfers (1858–1929), where a servile nude holds out a glass shade apparently made of peacock feathers, whose light will illuminate

its owner's work; or the sculptural candelabras of his compatriot Frans Hoosemans, in whose sensational solid-silver candleholders defenceless naked women carved from ivory are caught in the metal tendrils of giant predatory plants. In both of these undeniably decadent objects, woman and nature are literally intertwined, the undulating form of one synonymous with the being of the other.

Popular Style

Wolfers was, in fact, a supremely gifted jeweller and maker of *objets d'art*, perhaps second only to Lalique in this period. Like the French master, he combined human and animal, often entomological, life in his lavish creations. Like those of Lalique, these pieces often combined precious stones with processes such as enamelling in a way that is characteristic of the eclectic, non-hierarchical outlook of Art Nouveau as a whole. Nevertheless, the conundrum persisted that despite Art Nouveau artists wanting to reach a wider public than just the old aristocratic and social elites, even the more modest products of the style were out of reach of the pockets of the ordinary worker. Quality costs, after all, and the fate of Art Nouveau's popularity, especially after the standout success of the style at the Exposition Universelle in Paris in 1900, was predictably the mass production of cheaper, less well-made designs, often by the same manufacturers responsible for the very best pieces. Continental designers tended not to have the same aversion to modern industrial methods as the followers of William Morris, but as new, mass-produced ranges aimed at the more modest budget began to saturate the market, critics already hostile became dismissive, and Art Nouveau masters who prospered beyond the period, such as van de Velde and Lalique, had soon abandoned the style.

Interiors

Nonetheless, in espousing the equality of all the arts and backing up the belief with interiors whose every detail was designed according to the same unifying vision, for a brief period Art Nouveau did indeed represent a genuine aesthetic revolution – one that exerted a profound if subtle influence on the next generation of artists and designers. The Paris gallery of Siegfried Bing had led the way in the mid-1890s in displaying entire rooms wholly designed by the likes of van de Velde, Gaillard, Édouard Colonna (1862–1948) and de Feure; the last three of this quartet designed showrooms for Bing's triumphant offering at the 1900 Paris Expo, an event visited by an estimated 50 million people, which saw the new style soar in popularity. As well as van de Velde, Belgian designers of whole interiors included Serrurier-Bovy, Paul Hankar (1859–1901) and, of course, Horta, the original interior of whose own house (1898, now the Horta Museum) in Brussels is one of only a few from the entire period that are still preserved. German and Austrian interior designers associated with the Secession movements in Munich and Vienna, as well as the Mathildenhöhe Artists' Colony at Darmstadt, included Richard Riemerschmid, Bernhard Pankok, Bruno Paul, Peter Behrens (1868–1940), Josef Hoffmann, Joseph-Maria Olbrich (1867–1908) and Koloman Moser. The Vienna group was influenced, as we have seen, by Mackintosh, whose unified rectilinear interiors inspired their own monumental style, while the Barcelona masterpieces of Gaudí, especially the Casa Batlló, are as otherworldly on the inside as they appear from without.

Horta's Houses

Alas, interiors are for living in, and most of the classic Art Nouveau designs are known to us only from photographs, having been 'renovated' by owners who had tired of the style as aesthetic

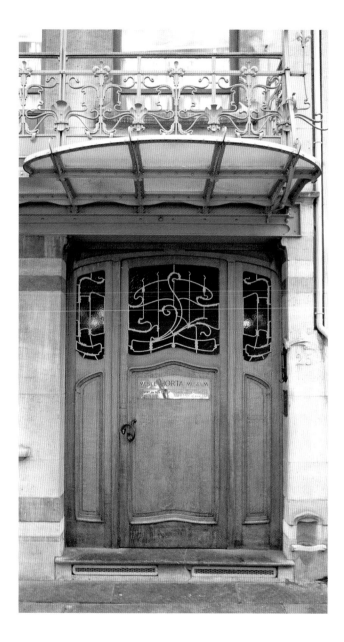

architectural daring will always startle more than any other aesthetic discipline. In the most distinctive buildings of the style, there is the same emphasis on decoration and natural curvilinear forms, but with the scale and complexity of architecture, the revolutionary nature of Art Nouveau, its break with the past, becomes patently obvious.

Horta's houses brought materials such as internally exposed brick, used in industrial buildings, or wrought iron and glass, previously associated with large public buildings such as the great European railway terminuses – into the realm of domestic architecture. Not only that, but a building's wrought-iron skeleton in his hands became an expressive element in its overall decorative scheme, while his use of glass roofs and walls in a domestic context began a tradition of light-filled interiors which, in breaking with nineteenth-century gloom, is a clear metaphor for the democratic era that was then emerging. Horta's houses and those of Hankar from the same period of the mid-to-late 1890s inspired other Brussels architects, such as Paul Cauchie (1875–1952) and Gustave Strauven (1878–1919) – the latter initially an assistant to Horta. The murals on the façade of Hankar's Hôtel Ciamberlani (1897), along with its distinctive large circular windows, became common features of architectural Art Nouveau.

Paris Icons

Horta's revolution was quickly absorbed by Guimard, whose Castel Béranger was the first Art Nouveau building in Paris. This led to the landmark Métro commission the following year, whose legions of curving plant-like lamps and glass-covered porches became instant icons of the city and gave rise to the name 'Le Style Métro', yet another designation for Art Nouveau. But the most prolific designer of Art Nouveau houses in Paris was Jules Lavirotte (1864–1924), whose buildings are characterized by lavish decoration of the façades. However, perhaps the most remarkable building of French Art Nouveau is the Villa Majorelle (1902) in Nancy, designed by Henri Sauvage (1873–1932) for the furniture- and glassmaker Majorelle. Intended as a showcase for his business, it was decorated throughout by specialists in various fields, with stained glass by Jacques Grüber (1870–1936) and a ceramic fireplace by Alexandre Bigot (1862–1927), not to mention Majorelle's own pieces.

fashion moved on. Most of those designers were also architects whose buildings exhibited such an aesthetic variety that it is at least as hard to speak of an architectural Art Nouveau as it is for other disciplines within the style. As with the other plastic arts, the nineteenth century had been a conservative period for architecture, its most characteristic buildings being stylistic revivals of old traditions. However, as the century of revolutions that began with Art Nouveau has shown,

Gaudí

The eccentricity of the style would be taken to a level of surreal genius by Antoni Gaudí in the late nineteenth century in the prosperous city of Barcelona. Inspired like so many Art Nouveau designers by the natural world, he once famously declared, 'There are no straight lines or sharp corners in nature. Therefore, buildings must have no straight lines or sharp corners.' Given the rectilinear traditions of Western architecture, this was an extreme philosophical position to adopt, but in drawing inspiration from plants and from the human skeleton, he developed revolutionary construction methods that confirmed his intuition that there were no better structural models than the ones which nature already offered. Thus walking beneath the catenary arches of the attic storey of the Casa Milà (1906–12) feels like passing through the spine of an animal, while the forest of supporting columns inside his still-unfinished cathedral, La Sagrada Familia (1882–), does indeed resemble a sacred grove of real trees. Here, the inspiration of nature, the most characteristic and most revolutionary aspect of the entire Art Nouveau style, is realized as a structural and aesthetic principle so complete that to associate his buildings with a particular style seems trivial and reductive. Nonetheless, Gaudí's sympathies were widely shared by others, if never realized with such depth and ingenuity.

Sharing the same city with Gaudí's unique masterpieces are several more works of Catalan Modernisme that stand with the finest buildings of Art Nouveau, including the Palau de la Música Catalana (1905–08)

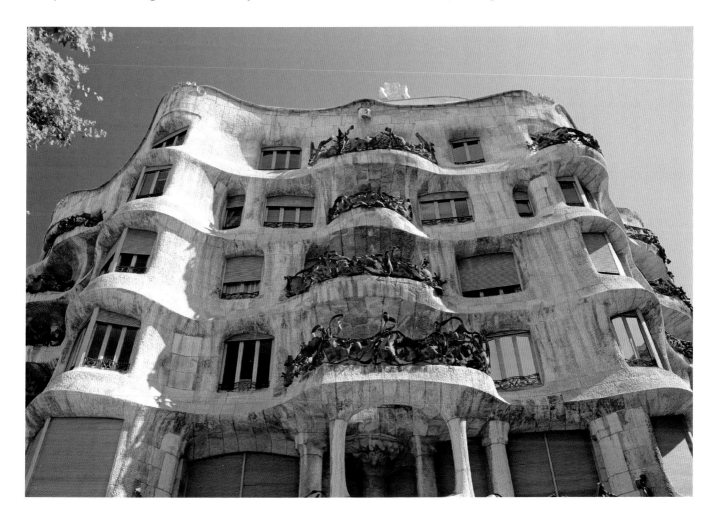

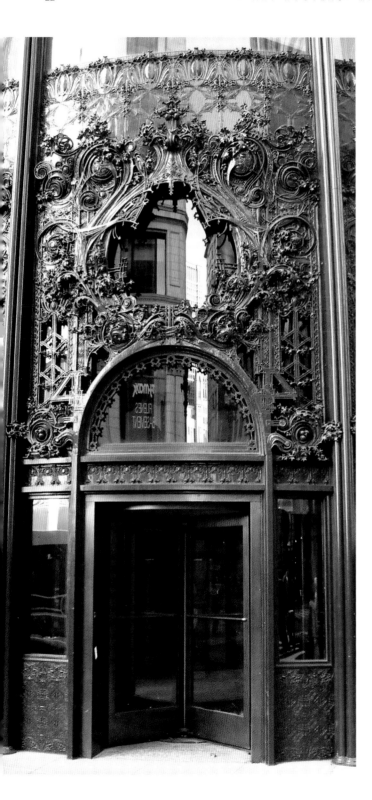

by Lluis Domènech i Montaner (1850–1923), with a stained-glass, bell-shaped auditorium ceiling that is among the most staggering creations in the style, and the many distinctive townhouses of Josep Puig i Cadafalch (1867–1956), such as the Casa Amatller (1898–1900), next door to Gaudí's Casa Batlló.

Sullivan's Skyscrapers

Art Nouveau also made a significant, if geographically limited, impact in America: in New York City, through the glassware and stained glass of Louis Comfort Tiffany, and in Chicago, through the skyscraper architecture of Louis Sullivan (1856–1924). The profuse architectural ornament Sullivan applied to the façades of commercial buildings, such as the Wainwright Building in St Louis (1890) or the Carson, Pirie, Scott store (now the Sullivan Center, 1899–1904) in Chicago, is as ornate as anything to be found in the style. Like so many Art Nouveau architects, including Horta, Guimard and Gaudí, Sullivan was strongly influenced by the ideas of the French architect and theorist Eugène Viollet-le-Duc (1814–79), not only in the use of iron as a construction material – an indispensable element in the skyscrapers for which the American is best known – but also for the importance the Frenchman placed on the structural models to be found in nature.

Spirit of the Times

The restless atmosphere in the West at the end of the nineteenth century, which led to the social, political and cultural revolutions of the following few decades, was undoubtedly a factor in the rise of Art Nouveau and the rejection of dead tradition. Art Nouveau artists, and especially its designers and architects, often were one-off originals such as Charles Rennie Mackintosh, who, like the other masters of the new style, had recognized that the spirit of his times demanded new forms of expression. His distinctive work as an interior designer in his home city led to a commission to design what is widely considered to be his masterpiece, the Glasgow School of Art (1897–1909). The restrained elegance of his style had a big impact on the development of Sezessionstil – as the Austrian form of Jugendstil was called – and especially on the work of Hoffmann and Moser.

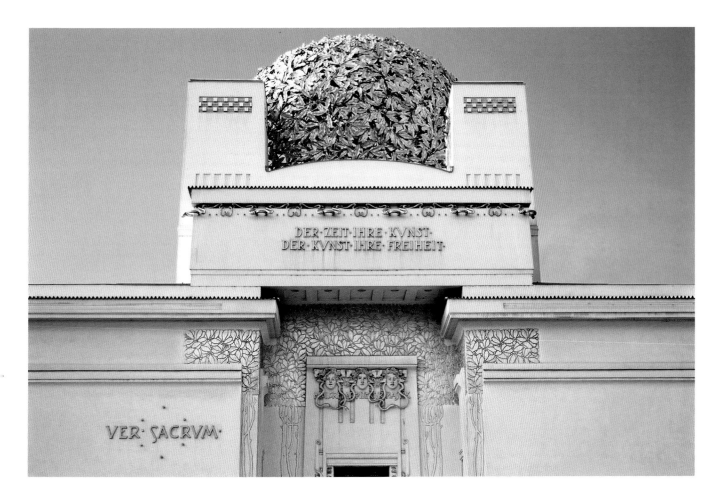

The Other Wagner

Hoffmann was working in the practice of Otto Wagner (1841–1918), the leading Viennese architect of the 1890s, during the period when Wagner was designing two of the most distinctive Art Nouveau buildings in the Austrian capital, the Medallion House and the adjacent Majolica House (both 1898–99), their façades elaborately decorated by Moser. A professor of architecture at the Vienna Academy, Wagner was nearly 60 by then, but still enthusiastically joined the Secession soon after it was founded by Hoffman, Klimt, Moser and other artists of the younger generation. Another founder member was Wagner's assistant, Joseph-Maria Olbrich, who for several years had worked with him on the design of stations for the *Stadtbahn*, the city's internal railway system, which opened in 1898; it was close to one of the finest of these entrance buildings, at Karlsplatz, that Olbrich was given the task of designing the official exhibition building for the Secession. Also opening in 1898, this modern equivalent of a classical temple, with its thick stone walls and cupola of gilded leaves, could hardly be further from the modern Gothic fantasies of Gaudí or Horta's light-filled townhouses. However, an exterior that might seem forbidding is in fact decorated with the same generosity as those other, more exuberant, structures, the Classical spirit actively brought to life in modern form rather than slavishly copied.

A Tower and a Palace

Olbrich's other great contribution to architecture before his early death was the construction of the majority of the buildings of the

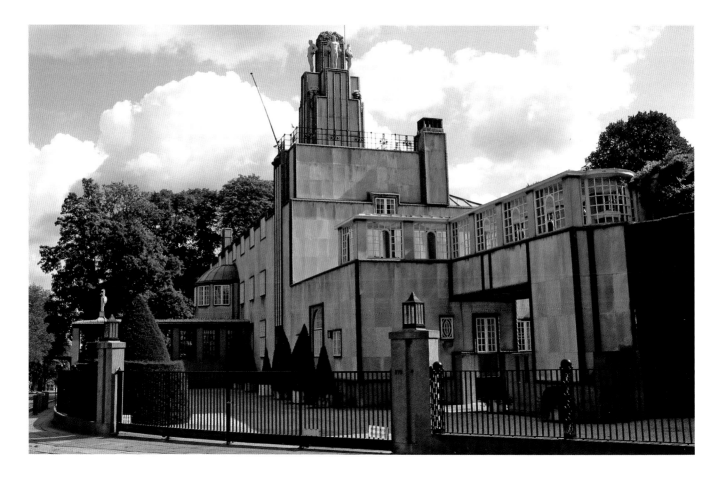

Mathildenhöhe Artists' Colony in Darmstadt in western Germany. Founded in 1899, and the brainchild of the visionary patron Ernest Ludwig, Grand Duke of Hesse (1868–1937), the colony was the most significant residential scheme associated with Art Nouveau or Jugendstil. In line with the progressive ideals of Art Nouveau, it was intended to showcase modern styles of living, and to that end, for each of the four exhibitions which took place there between 1901 and 1914, a new series of artists' houses was constructed on the site. Olbrich was extensively involved in the first three, designing houses and interiors and, for the third exhibition in 1908, the exhibition hall and *Hochzeitsturm*, or Wedding Tower, whose distinctive five-fluted apex points to the sky like a five-fingered hand.

In fact, the rational simplicity of the Wedding Tower points the way towards Art Deco, a style not long in the future, and this is true of another late masterpiece of Art Nouveau, the Stoclet Palace (1905–11), a large private house in Brussels, designed by Hoffmann in the starkly geometric style which the Wiener Werkstätte had adopted by then. The most fully realized *Gesamtkunstwerk* of the entire period, Hoffmann even conceived it as a total artwork in the spirit of Wagner, and to this end, brought in many of the greatest designers and artists from the Werkstätte or Secession, including Moser and Klimt, to help decorate it.

One of the others who worked on the project was the ceramicist Richard Luksch (1872–1936), who specialized in ceramic figures or reliefs. Ceramics were another area in which the experimental spirit of Art Nouveau transformed a previously unadventurous art form into a field of novelty and surprise, the new style giving licence to explore new types of glaze – metallic lustres in the case of Clément Massier (1845–1917) – or eccentric new shapes – as in the work

of Edmond Lachenal (1855–1948) – sometimes modelled on fruits or vegetables and fired with complex glazes. Ceramics were also given new applications, being used, for instance, on the façades of buildings, as with the architect Jules Lavirotte, whose elaborate designs for his own so-called Ceramic Hotel (1904) in Paris were realized by the ceramics manufacturer Alexandre Bigot.

Tiffany

Stained glass was yet another minor art which had been all but forgotten by fine artists. Rediscovered in the 1850s during the Gothic Revival, the flattening of hierarchies that was central to Art Nouveau saw fine artists willingly accept commissions, sometimes on a large scale, for new works in the medium. Bing encouraged members of Les Nabis to make stained-glass pieces to sell in his gallery, while Grüber of the École de Nancy supplied stained-glass windows and panels for houses in the city, such as the Villa Majorelle. Religious institutions also commissioned modern stained-glass windows from the likes of Mucha (for the Gothic St Vitus Cathedral in Prague); sometimes these were needed for a wholly new building, as in the case of Moser's suite of windows for Otto Wagner's Art Nouveau Church of St Leopold, known as the Kirche am Steinhof (1907, see page 50), in Vienna.

Without question, the most significant stained-glass artist of the period was Louis Comfort Tiffany. Most famous for his range of lamps, in particular the celebrated Wisteria Lamp (1901), early in his career, while in Paris for the Expo of 1889, Tiffany saw the work of Gallé and was deeply impressed. He developed a revolutionary new method for joining pieces of glass, which he called the copper foil technique, where small bits of glass edged in copper were soldered together into their final form, the finished design being light enough on account of the copper to be fashioned into a lamp. Originally a painter himself, Tiffany also developed a new type of iridescent glass he called *Favrile*, which allowed for a level of tonal complexity in larger two-dimensional images that enabled him to rival the effects of oil painting in the subtlety with which he represented the physical world. This is evident in exquisite landscape scenes such as *Magnolias and Irises* (c. 1908, see right and page 124), originally designed as a memorial window for a family mausoleum.

Italy and Holland

By the time the Art Nouveau style had spread to America, its influence across Europe following the 1900 Paris Expo and the 1902 Turin Expo had reached an absolute peak. The Turin exhibition gave international exposure to Italian furniture makers such as Carlo Bugatti (1856–1940), a self-taught original whose eccentric work, inspired by North African traditions, was an instant hit. By then the Art Nouveau style had already been taken up by designers in Italy, such as potter and

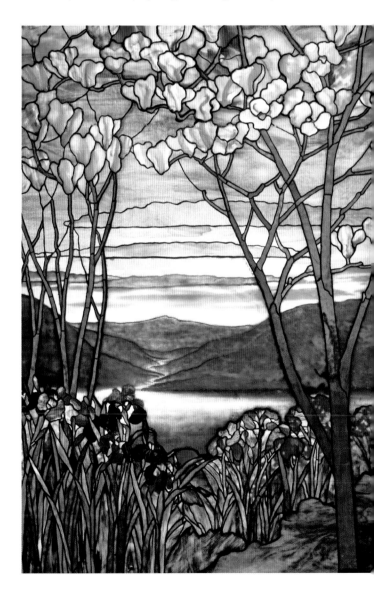

painter Galileo Chini (1873–1956, *see* page 99), Russian-born German artist Adolfo Hohenstein (1854–1928), the father of Italian poster art, and Manuel Orazi (1860–1934), who in 1896 produced jewellery for Bing's gallery in Paris and, later, posters for La Maison Moderne (*see* page 103).

The roster of international names courted by Bing also included Dutch designers such as Johan Thorn Prikker (1868–1932), whose Symbolist paintings of the early 1890s – for instance, *Bride of Christ* (1892–93, *see* page 85) – exhibit all the priorities of line and decoration that became synonymous with Art Nouveau. In 1898, Thorn Prikker established the Arts and Crafts Gallery in The Hague, where one of the exhibitors was his friend, the painter Jan Toorop (1858–1928). Born and raised in Indonesia, Toorop painted in a variety of styles, but Symbolist paintings such as *The Three Brides* (1892–93, *see* page 86)

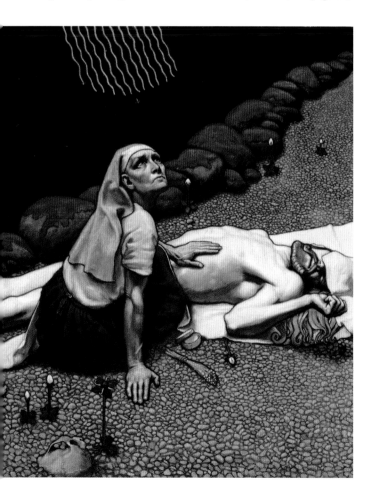

combine a strong curvilinear design with his knowledge of Javanese shadow puppets in a unique aesthetic whose qualities are also evident in advertising posters he designed during the same period.

Hungary and Finland

Beyond industrializing countries in Western Europe, Art Nouveau spread into nations in the East in either the Austrian or Russian spheres of influence. In Hungary, the catalyst for the new style was the painter József Rippl-Rónai, a one-time member of Les Nabis and exhibitor at Bing's gallery, who made designs for furniture, tapestry, glassware, ceramics and stained glass. Typical of these is the large embroidery *Dame en robe rouge*, now owned by Budapest's Museum of Fine Arts; the museum's building is itself an exceptional example of Art Nouveau architecture, designed by Ödön Lechner (1845–1914), the country's leading architect in the style.

The arts in Nordic countries had been in thrall for decades to an aesthetic known as National Romanticism, which placed language, folk art and national myth at the heart of artistic concerns. In the late 1890s in Finland, then under Russian rule, the painter Akseli Gallen-Kallela (1865–1931) produced a series of large oil paintings depicting scenes from the *Kalevala*, the national epic poem, combining the nationalist aesthetic with the new style. For their clarity of colour and stylized, decorative design, paintings such as *Lemminkäinen's Mother* (1897, *see* left and page 93) rank among the finest images of Art Nouveau. On the basis of these masterpieces, Gallen-Kallela was selected to decorate the Finnish pavilion at the 1900 Paris Expo, a building designed by Eliel Saarinen (1873–1950), the architect later responsible for the Finnish capital Helsinki's main railway station (1904), the most significant Nordic building in the style.

Decline and Demolition

Elsewhere, cities in Eastern Europe aspiring to be modern – such as Prague, Moscow and Riga – saw a sudden growth of buildings in the Art Nouveau style during the first decade of the twentieth century. But even as others caught on, the original market dried up. An economic downturn made the higher-end products affordable only

to a much smaller clientele; but, in any case, as the novelty of Art Nouveau began to pale, and as increasing numbers of second-rate commercial items led to poorer aesthetic standards, the harangues of those critics who had never liked it became the majority view. By the time the First World War began to tear into pieces ideas of a common international culture which had helped the spread of Art Nouveau, there was no significant artist or designer still working in the style. When the war ended, the decorous excesses of the Belle Époque in general – and of Art Nouveau in particular– seemed anathema to most artists, with the emphasis on nature now seen as backward, irrational, even dangerous. A new mood had descended on the world, a rational faith in technology as the engine of progress, best exemplified in the famous maxim of Le Corbusier (1887–1965) that a house is 'a machine for living in', Art Nouveau buildings, in particular, suffered the backlash. Their profuse decoration and eccentric design made them emblems of a decadent era and thus fair game for redevelopment, an attitude which saw classic structures such as Horta's Maison du Peuple (1899) simply razed and replaced over the coming decades.

Holistic Legacy

Since the 1960s, Art Nouveau and its artefacts have been steadily rediscovered and reassessed, and its influence can perhaps be seen in the quirky eccentricity of Postmodern design. However, long before that, even as it was being derided and then forgotten, Art Nouveau had bequeathed something important to modern art and design which has persisted to this day: a belief in modernity itself. Indeed, some of its practitioners, such as the artist-turned-architect Peter Behrens, became leading figures in the Modernist movement; not only, in the case of Behrens, for his groundbreaking designs, but also for training pivotal figures of the coming International Style, such as Le Corbusier, Walter Gropius (1883–1969) and Ludwig Mies van der Rohe (1886–1969). All three accepted the basic premise of Art Nouveau that designers should concern themselves with the total environment in which people lived and worked, and the Bauhaus school of art and industrial design, which first Gropius and then Mies would go on to lead during the Weimar Republic, was guided by that holistic philosophy. What they eschewed, what would only begin to re-emerge

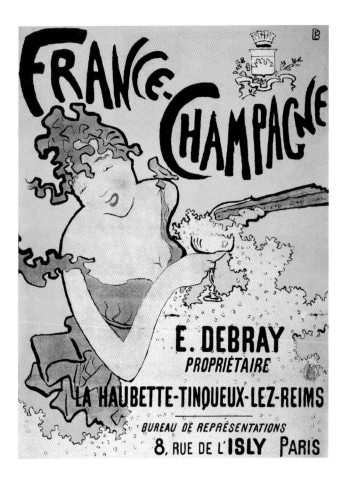

with the rise of Postmodernism, was a belief in decoration that was central to the worldview and the visual language of Art Nouveau.

Many of those Art Nouveau designers who did not embrace the rigorous Modernism of the Bauhaus nevertheless adapted to the new conditions after the war. Lalique turned from jewellery to glass, conceiving sleek modern designs that celebrated the speed of the Jazz Age – icons of Art Deco, the direct descendant of Art Nouveau, in which any decoration is rationalized – disciplined by the efficiency of the machine. However, in the commercial appeal of so much Art Deco design, we can see the influence of its predecessor. Art Nouveau was the first modern style in part because it understood desire as much as design. A movement of many brilliant individuals, its tolerance and lack of dogma were fundamentally democratic, offering a promise of beauty and adventure to which modern men and women felt they could all aspire.

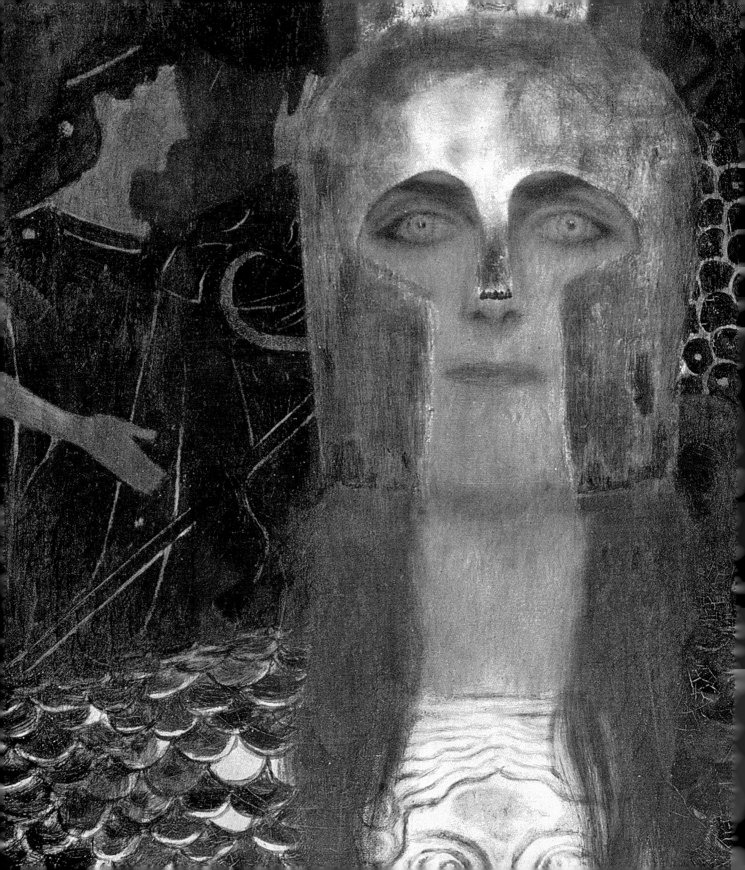

Austria & Germany

Art Nouveau was known as Jugendstil in Germany after the Munich journal *Jugend*, which promoted the style. In Vienna it was known as Sezessionstil, after the arts organization to which the most prominent artists and designers all belonged.

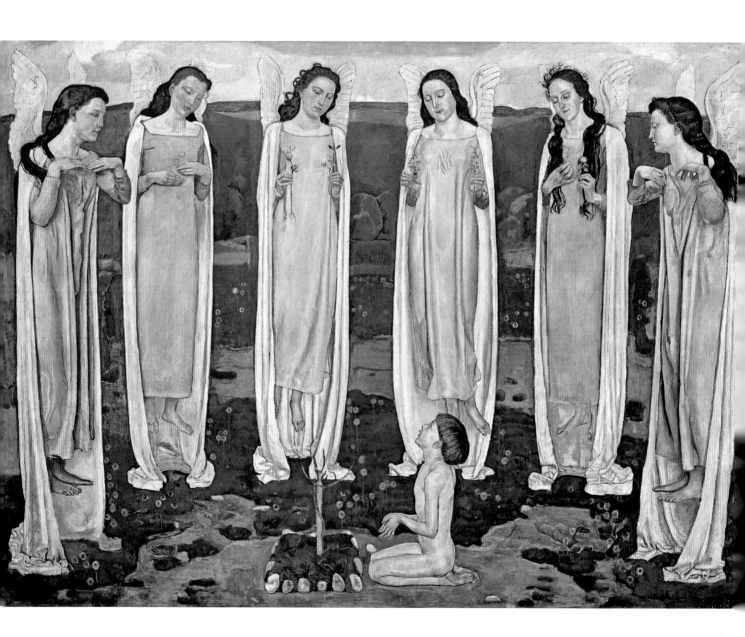

Ferdinand Hodler (1853–1918)
Tempera and oil on canvas, 219 x 296 cm (86¼ x 116½ in)
• Kunstmuseum, Bern

Der Auserwählte (The Chosen One), 1893–94 A painter of often monumental images of arcane ritual, today Hodler is among the most underrated artists of the period. After success at the 1900 Paris Exposition, he was invited to join both the Berlin and Vienna Secessions.

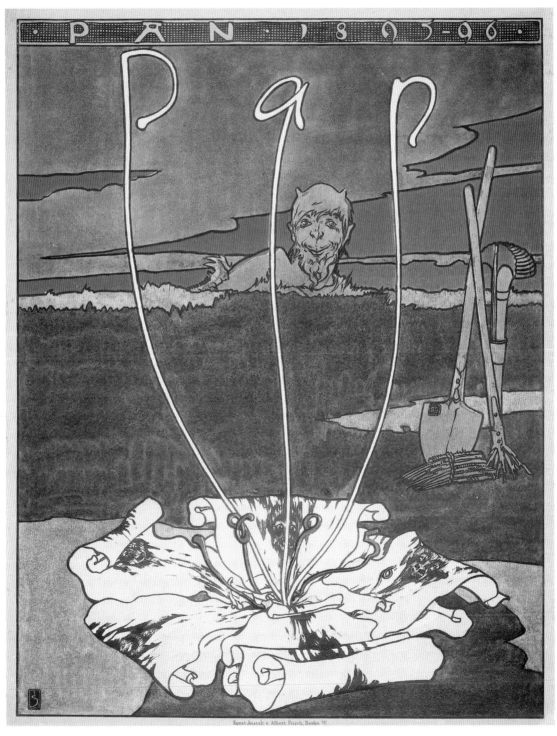

Joseph Sattler (1867–1931)
Colour lithograph, 34.3 x 26.7 cm (13½ x 10½ in)
• Minneapolis Institute of Art, Minnesota

Cover of *Pan*, 1895 A German painter and illustrator, Sattler is most famous for his graphic art for *Pan*, the Berlin-based journal which was the first publication to spread the Art Nouveau style in Germany.

Ferdinand Hodler (1853–1918)
Watercolour on card, 95 x 65 cm (34⅔ x 25½ in)
• Kunsthaus Zurich

The Dream, 1897 The greatest Swiss artist of his generation, Hodler was a gifted painter of landscapes as well as symbolic, decorative pictures strongly aligned with Art Nouveau, such as this delicate, allegorical work.

Otto Eckmann (1865–1902) **Waldteich, *c.* 1898** In his late twenties Eckmann switched from painting to the
Tapestry applied arts, making designs for commercial firms such as Deuss & Oetker in
 Krefeld. He also designed two Jugendstil type fonts that are still in use today.

Hermann Obrist (1863–1927)
Brocade in silk and cotton, with gold thread and silk embroidery

Fire Lilies embroidery, 1898 Swiss-born Obrist's botanical training is evident in his furniture and ceramics, but also in textiles like this exemplary work of Jugendstil, dating from the late 1890s, after he had moved his workshop from Italy to Munich.

Peter Behrens (1868–1940)
Colour woodcut, 28.5 x 20.5 cm (11¼ x 8 in)
• Museum für Kunst und Gewerbe Hamburg

The Kiss, 1898 Behrens is best known today as the Modernist architect who designed the AEG Factory (1910) in Berlin. However, he began his career as a painter and produced this classic Jugendstil print while a member of the Munich Secession.

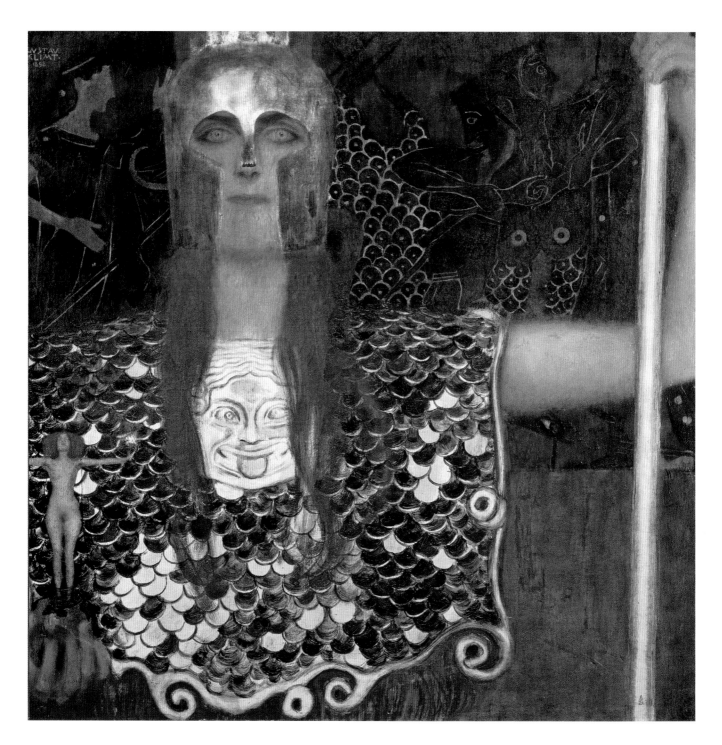

Gustav Klimt (1862–1918)
Oil on canvas, 75 x 75 cm (29½ x 29½ in)
• Wien Museum, Karlsplatz, Vienna

Minerva or Pallas Athena, 1898 The model's erect pose and steely gaze; the tiny human figure standing, possibly alive, in her open hand; the glint of light on gold armour; the cut-off composition – all these factors contribute to the power of this mysterious painting.

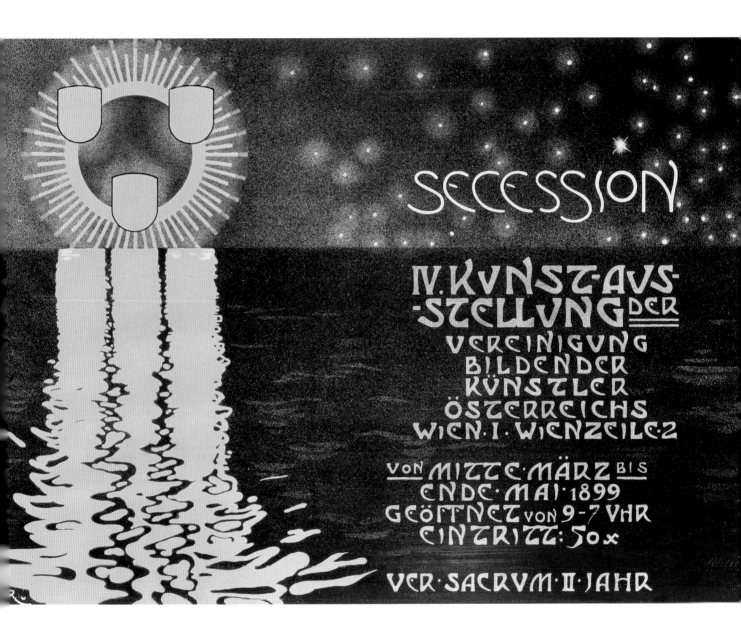

Alfred Roller (1864–1935)
Colour lithograph, 30 x 23.05 cm (11⅘ x 9 in)
• Private Collection

Poster for the 4th Vienna Secession, 1899 A founding member of the Vienna Secession, Roller was a painter and set designer who also produced posters for the organization, as well as covers and illustrations for *Ver Sacrum*, its official publication.

Joseph-Maria Olbrich (1867–1908)
Stained-glass window
• Hessisches Landesmuseum, Darmstadt

Stained-glass window, *c.* 1901 Another founding member of the Vienna Secession, in 1899 Olbrich moved to Darmstadt to help set up the Mathildenhöhe Artists' Colony, where he produced this image in stained glass, an art form revived in this period.

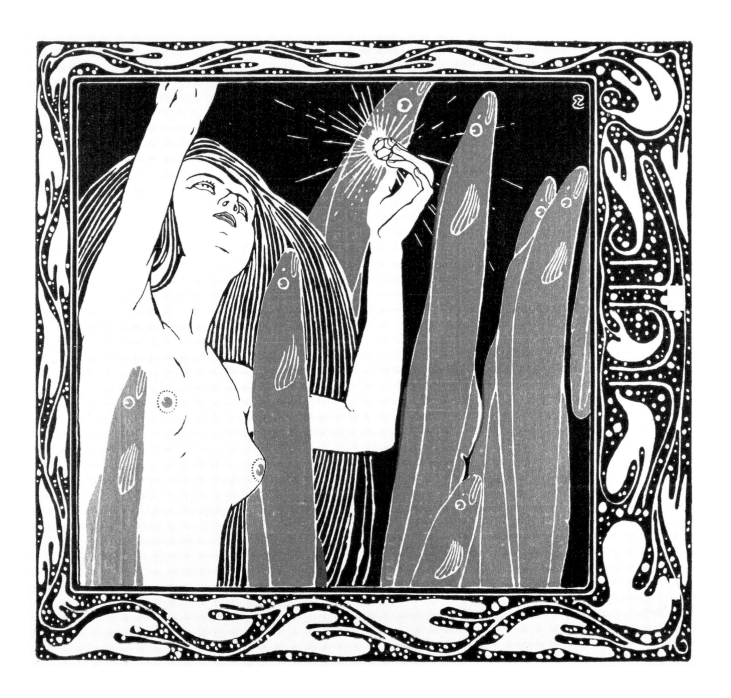

Koloman Moser (1868–1918)
Colour lithograph

Calendar Sheet: July 1901 An artist and designer of everything from ceramics to stained glass, and from postage stamps to silverware, Moser was one of the founder members of the Vienna Secession and co-founder of the Wiener Werkstätte.

Joseph-Maria Olbrich (1867–1908)
Drawing • Hulton Fine Art Collection

House at Darmstadt, designed by Professor Joseph Olbrich, 1901–02 An architect who had already designed the Secession Building in Vienna, over the course of a decade in Darmstadt, Olbrich designed more than a dozen artists' houses as well as an exhibition hall and a signature tower.

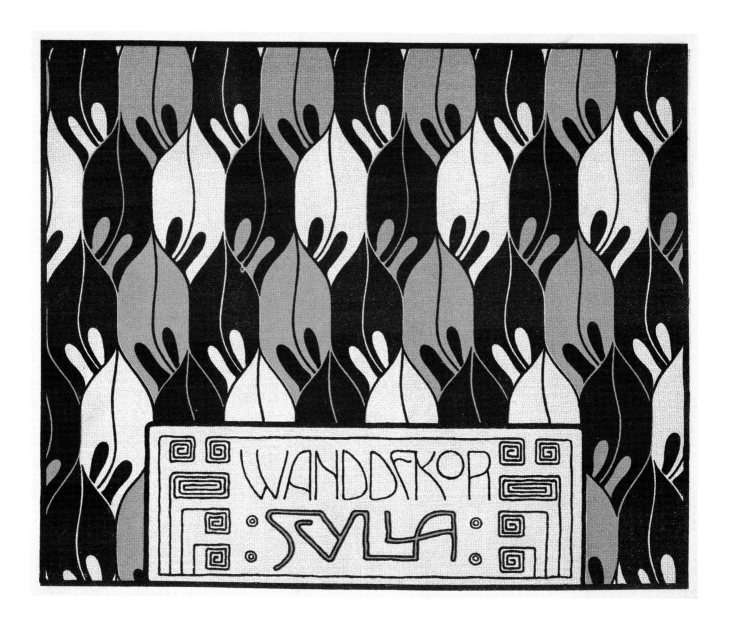

Koloman Moser (1868–1918)
Colour lithograph, 25 x 29.5 cm (9⅘ x 11⅝ in)
• Harvard Art Museums/Busch-Reisinger Museum, Massachusetts

Surface area (wall) decoration, Scylla, 1901 This design, originally for wallpaper, was included in *Die Quelle* (The Source), a portfolio Moser published of patterns that could be applied to other surfaces such as textiles and tapestries.

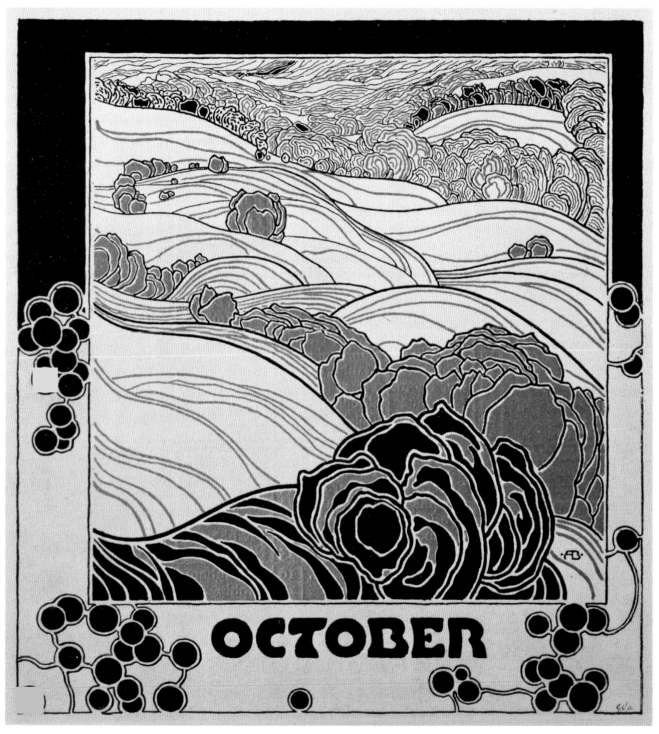

OCTOBER

Adolf Böhm (1861–1927)
Woodcut • Private Collection

October, 1901 Another founder member of the Vienna Secession, Böhm was a designer of furniture and ceramics as well as a painter and graphic artist who produced work for *Ver Sacrum*, the Secession's official magazine.

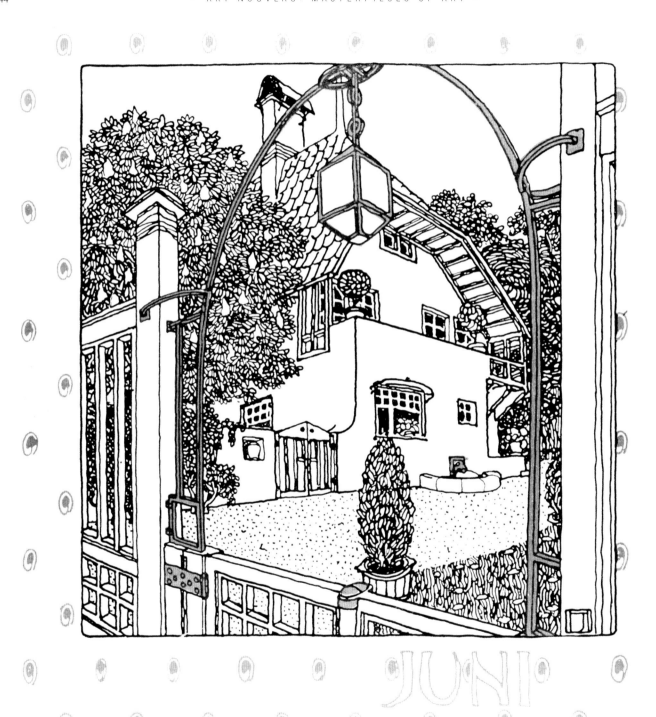

Josef Hoffmann (1870–1956)
Colour lithograph, 27.25 x 30 cm (10¾ x 11⅘ in)

Calendar sheet for *Ver Sacrum*, Volume 4, 1901 Principally an architect, Hoffmann was another founder member of the Secession and co-founder of the Wiener Werkstätte, for which he designed tableware, lamps and several chairs now considered to be design classics.

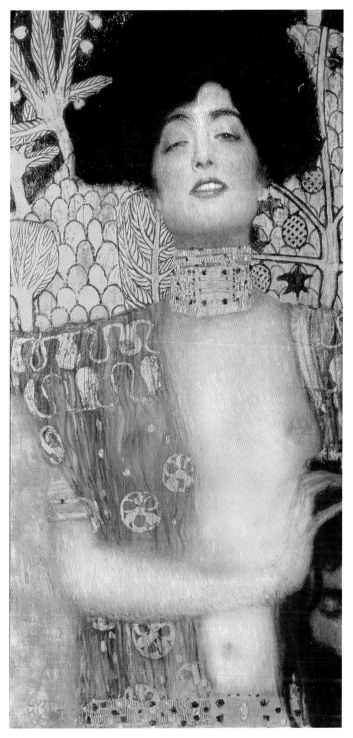

Gustav Klimt (1862–1918)
Oil on canvas, 84 x 42 cm (33 x 16½ in)
• Österreichische Galerie Belvedere, Vienna

Judith, 1901 Still semi-naked from seducing Holofernes, and in a clear elision of sex and death, in this still-shocking image, the Jewish heroine is more Salome than Judith, holding the trophy of Holofernes' head, ecstatic at what she has done.

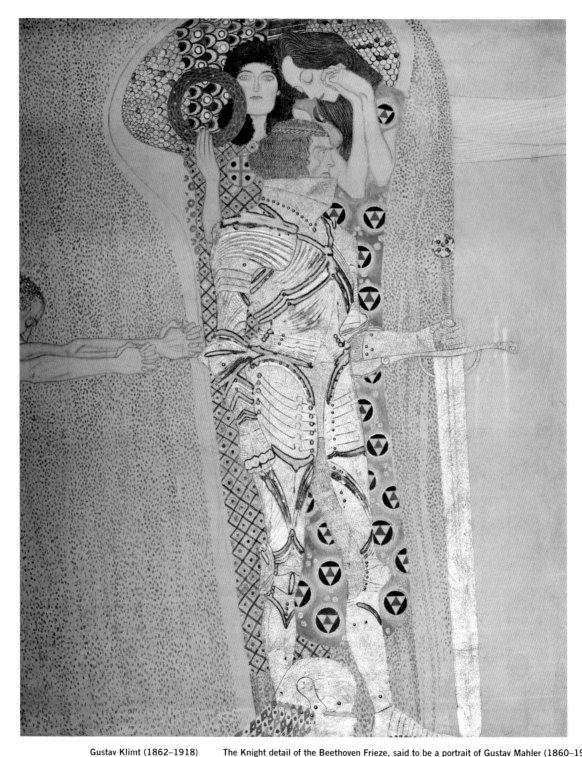

Gustav Klimt (1862–1918)
Fresco (whole frieze) 213.36 x 3413.76 cm (84 x 1344 in)
• Österreichische Galerie Belvedere, Vienna

The Knight detail of the Beethoven Frieze, said to be a portrait of Gustav Mahler (1860–1911), 1902
The *Beethoven Frieze* was painted for the 14th exhibition at the Secession Building in Vienna. It was originally intended as part of a *Gesamtkunstwerk* in tribute to the composer, comprising many pieces by different artists.

Alfred Roller (1864–1935)
Lithograph, 26.2 x 77.5 cm (10⅓ x 30½ in)
• Victoria and Albert Museum, London

Poster for the 16th Vienna Secession, 1903 In this poster, the letter 'S' in Secession becomes a graphic structural line, linking the top and bottom of the poster across a wide area of decorative space. The typeface is one of many created by members of the group.

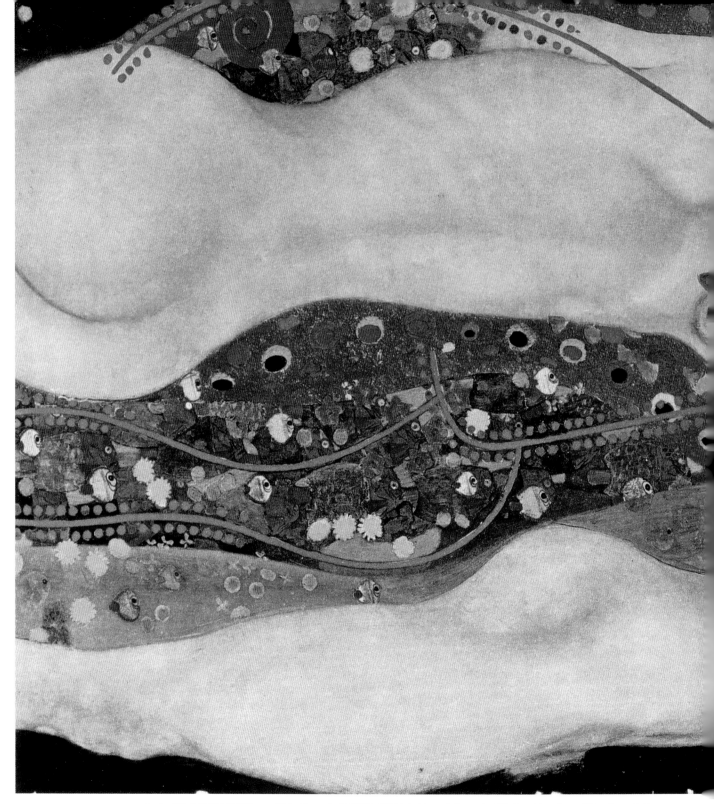

Gustav Klimt (1862–1918)
Tempera and watercolour on parchment, 80 x 145 cm (31⅔ x 57 in)
• Private Collection

Water Serpents II, 1904–07 Painted towards the end of Klimt's golden phase, *Water Serpents II* is a depiction of lesbian love disguised on the one hand by its extravagant decoration, and on the other by its vague reference to myth.

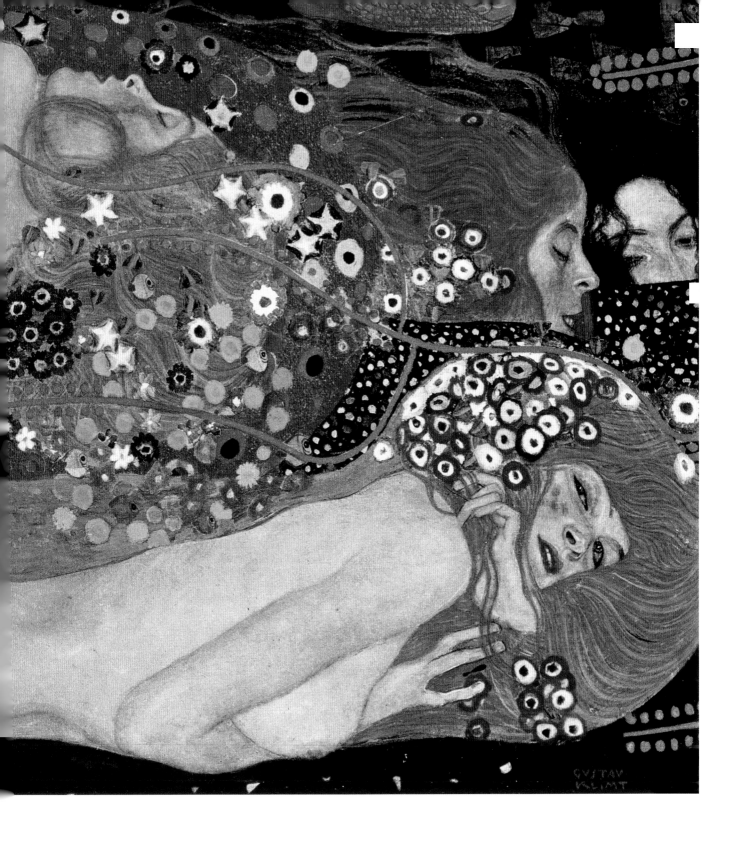

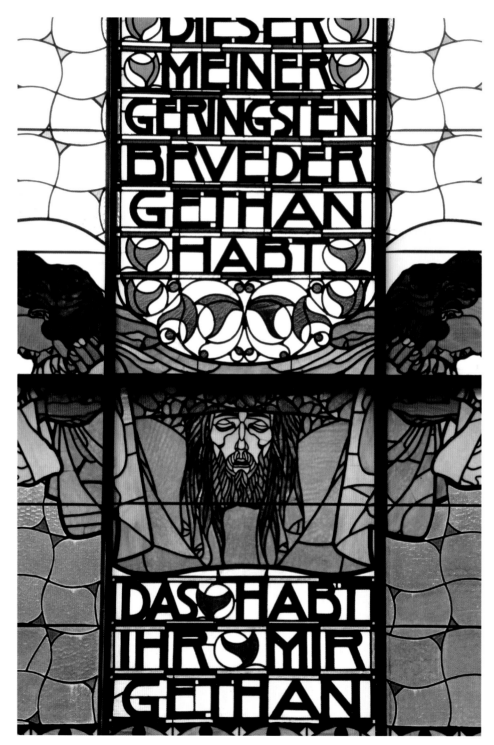

Koloman Moser (1868–1918)
Stained glass • Steinhof Church (St Leopold), Vienna

Stained-glass window, The Veil of Veronica, 1904–07 The impressively versatile Moser was commissioned by the architect Otto Wagner to design a suite of stained-glass windows for his new Church of St Leopold in the grounds of the Steinhof Psychiatric Hospital in Vienna.

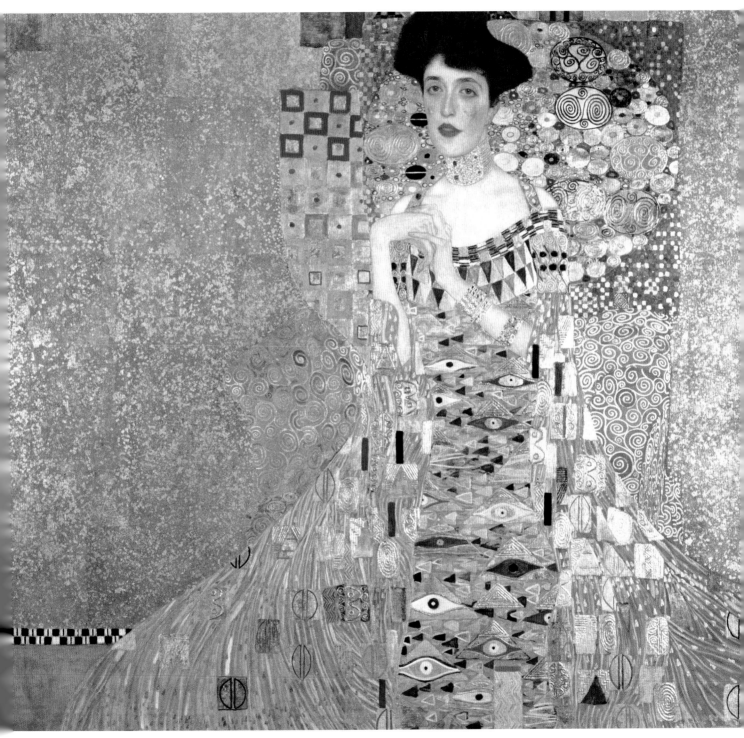

Gustav Klimt (1862–1918)
Oil, silver and gold on canvas, 138 x 138 cm (55 x 55 in)
• Neue Galerie New York

Portrait of Adele Bloch-Bauer I, 1907 Klimt's great painting of his most famous model
is the crowning achievement of his golden phase, which saw fine art raised to a pitch of
almost religious ecstasy through an abundance of teeming decoration.

France & Belgium

Art Nouveau is known by its French name because it began in Paris and in the partly French-speaking city of Brussels. It was here, too, that the art of the poster was born in the first consumer age.

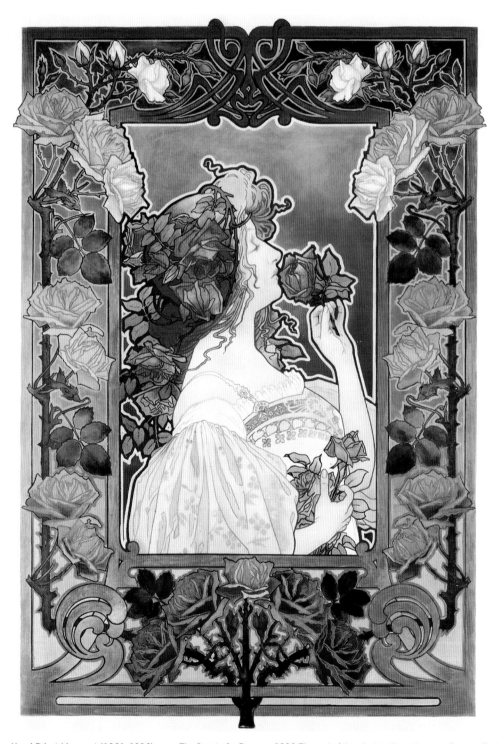

Henri Privat-Livemont (1861–1936)
Oil on canvas, 132 x 92 cm (52 x 36¼ in)
• Private Collection

The Scent of a Rose, *c.* 1890 The end of the nineteenth century saw the growth of a new industry, commercial advertising, and the simultaneous rise of a new kind of artwork to serve it. The Belgian artist Privat-Livemont was a pioneer of the advertising poster.

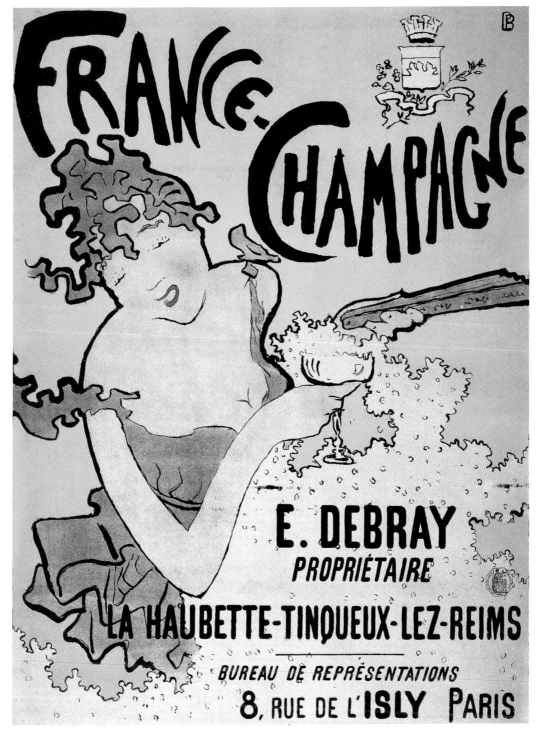

Pierre Bonnard (1867–1947)
Colour lithograph, 80.4 x 60.4 cm (31⅔ x 23¾ in)
• Van Gogh Museum, Amsterdam

France-Champagne, French advertising poster, 1891 In this poster, the young Bonnard draws on the characteristics of Japanese *Ukiyo-e* prints: the flat colour, clear outlines, elevated viewpoint and simplified forms are all traits he learned from Japanese art.

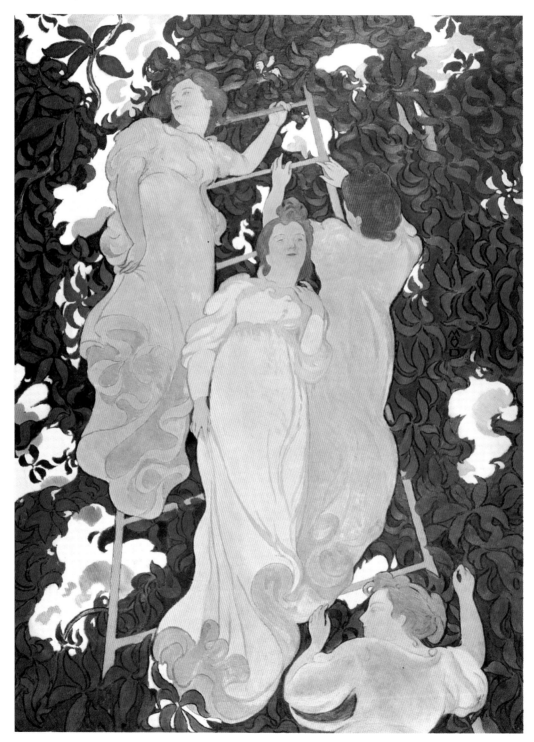

Maurice Denis (1870–1943)
Oil on canvas, 235 x 172 cm (92½ x 67¾ in)
• Musée Maurice Denis, Saint-Germain-en-Laye

The Ladder in the Foliage, 1892 Denis was a member of Les Nabis and contributed work to the Paris gallery of Siegfried Bing. In this highly improbable, decorative painting, the swirls of the women's dresses mirror the foliage around them.

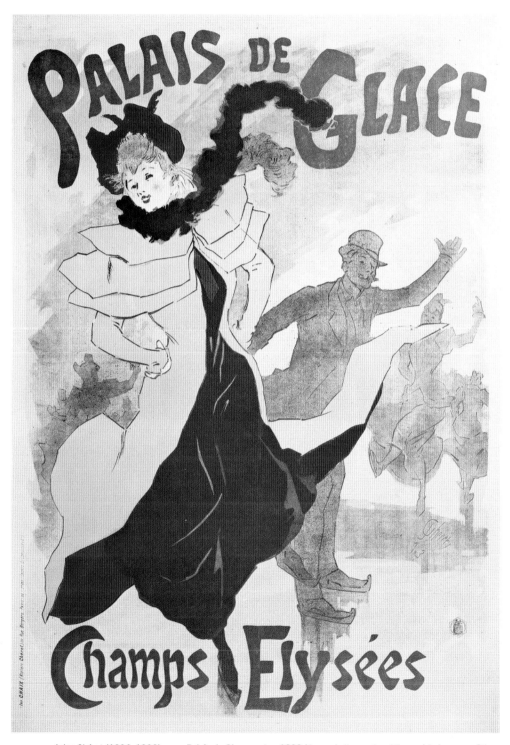

Jules Chéret (1836–1932)
Lithograph, 124.1 x 88.3 cm (48⅞ x 34¾ in)
• Lord's Gallery, London

Palais de Glace poster, 1893 No one better captured the social pleasures of the Belle Époque than Jules Chéret. In this instance, the excitements of ice-skating on the Champs-Élysées are perfectly conveyed by his giddy graphic style.

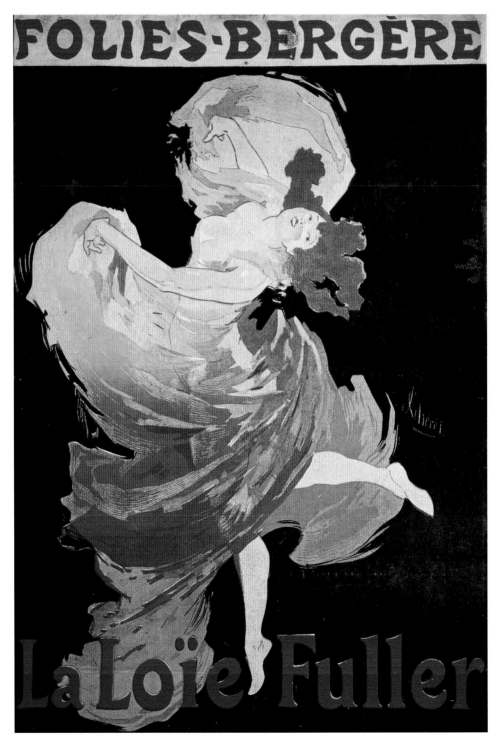

Jules Chéret (1836–1932)
Lithograph, 123.8 x 87 cm (48¾ x 34¼ in)
• Private Collection

Poster advertising Loïe Fuller at the Folies Bergère, 1893 Loïe Fuller (1862–1928) was a pioneer of modern dance in *fin-de-siècle* Paris, whose performances combined extravagant costumes with innovative lighting to create the swirling spectacle suggested in this poster.

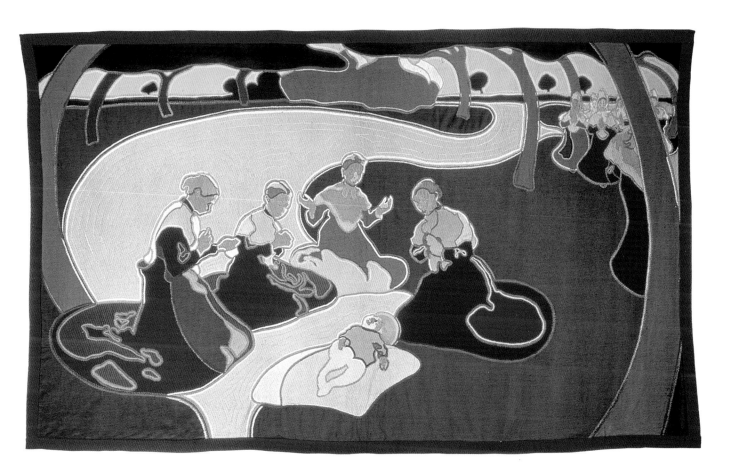

Henry van de Velde (1863–1957)
Wall hanging of appliqué, wool and silk, 137 x 229 cm (54 x 90 in)
• Kunstgewerbemuseum, Zurich

La Veillée des Anges (Angels' Wake), 1893 One of the most versatile of all the Art Nouveau designers, van de Velde started out as a painter. This wall hanging is strongly suggestive of the simplified Symbolist style of Gauguin and Les Nabis.

Paul Sérusier (1864–1927)
Oil on canvas, 110.8 x 101 cm (43⅔ x 39¾ in)
• Dallas Museum of Art, Texas

Celtic Tale, 1894 Sérusier was a key member of Les Nabis and a devoted follower of Gauguin. In this work, the mythic content and the stylization of line and colour combine to create a highly decorative painting.

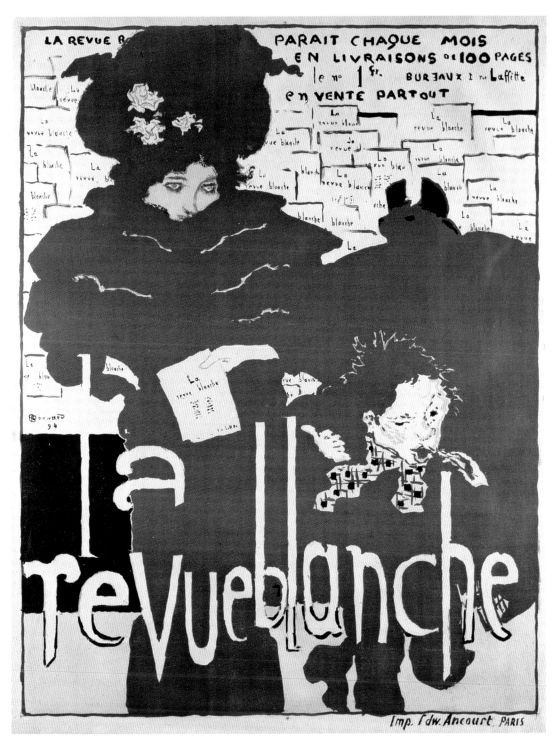

Paul Bonnard (1867–1947)
Colour lithograph, 80 x 62 cm (31⅔ x 24⅔ in)
• The Higgins Art Gallery and Museum, Bedford

La Revue blanche, 1894 This ambiguous cover design for *La Revue blanche*, Paris's leading journal of art and literature from 1889 to 1903, uses a large area of brown to flatten the two bodies and varied type elements to disrupt the scene.

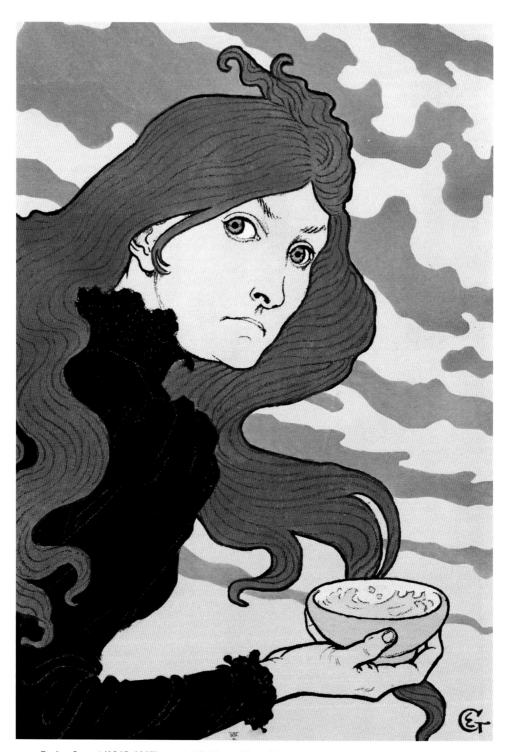

Eugène Grasset (1845–1917)
Colour lithograph, 39.7 x 27.6 cm (15⅔ x 10⅘ in)
• Museum of Fine Arts, Boston, Massachusetts

La Vitrioleuse (The Acid-thrower), 1894 Swiss-born Grasset found lasting fame with his poster art. This alarming image of a vengeful working-class woman, green-faced with jealousy, reflects the misogyny and class contempt endemic in patriarchal late-nineteenth-century Europe.

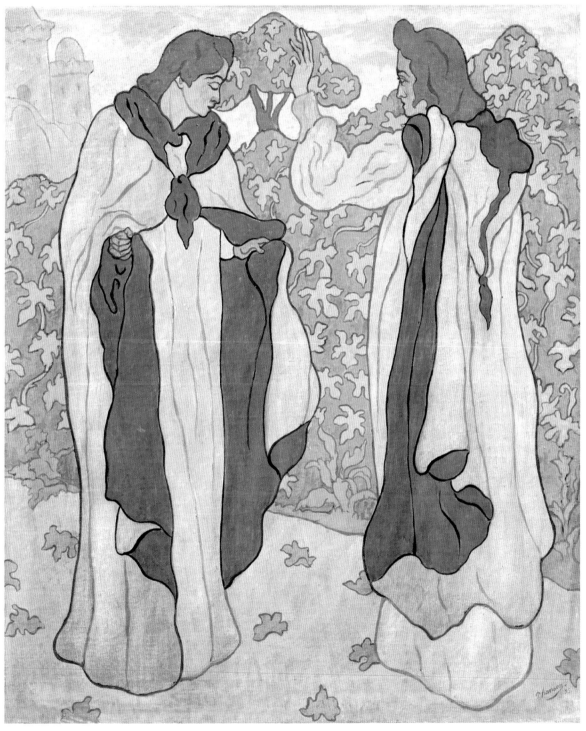

Paul Ranson (1864–1909)
Oil on canvas, 85 x 70.5 cm (33⅔ x 27¾ in)
• Private Collection

The Two Graces, 1895 Of all the members of Les Nabis, Ranson was most intuitively drawn to decorative art. This image inhabits a similar world to the medievalism of the Pre-Raphaelites, but with much greater stylization of colour and line.

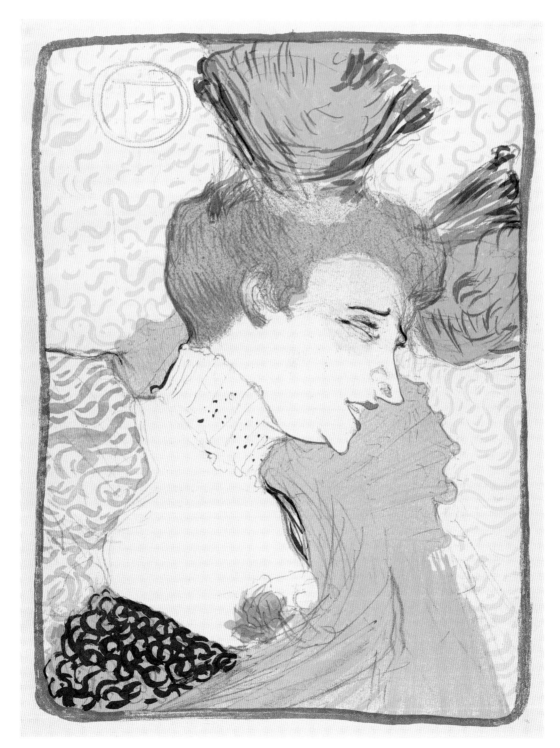

Henri de Toulouse-Lautrec (1864–1901)
Crayon, brush and spatter lithograph printed in eight colours,
Image: 32.9 × 24.4 cm (12⅔ x 9⅜ in); Sheet: 36.8 x 27.9 cm
(14½ in x 11 in) • The Metropolitan Museum of Art, New York

Mademoiselle Lender, 1895 Marcelle Lender (1862–1926) was a singer, dancer and
entertainer in the theatres of Montmartre in Paris, the district where Toulouse-Lautrec
lived and painted for the last two decades of his life.

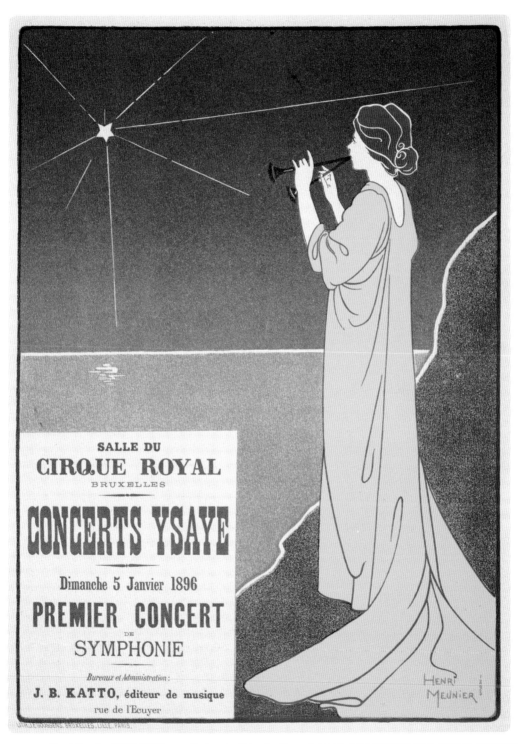

Henri Meunier (1873–1922)
Colour lithograph, 125 x 89 cm (49¼ x 35 in)
• Private Collection

Poster advertising the 'Ysaye Concerts', Salle du Cirque Royal, Brussels, 1895 This poster by the Belgian artist is classic Art Nouveau: green water, blue sky, yellow dress, red hair, red-brown rocks – all rendered in block colours that make the image clear, immediate and fit for commercial purpose.

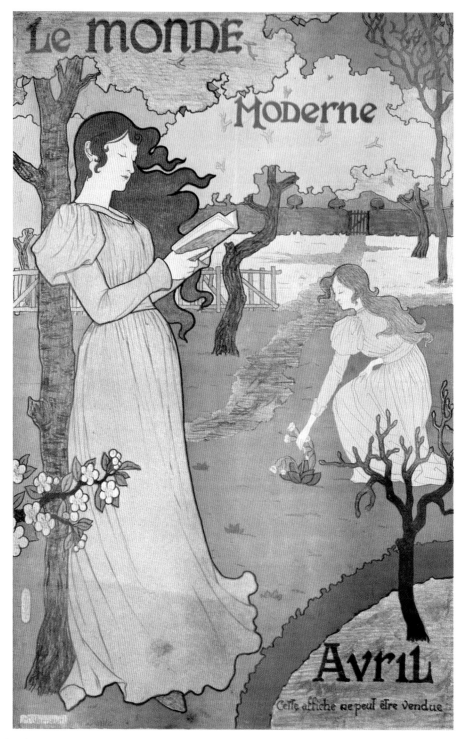

Maurice Pillard Verneuil (1869–1942)
Colour lithograph, 42.6 x 64.2 cm (16¾ x 25¼ in)

Le Monde Moderne, **poster, advertising the April issue of the journal, 1896** *Le Monde Moderne* was an illustrated journal that first appeared in 1895. Verneuil was trained by Eugène Grasset and was strongly influenced by Japanese art, as is clear from this image.

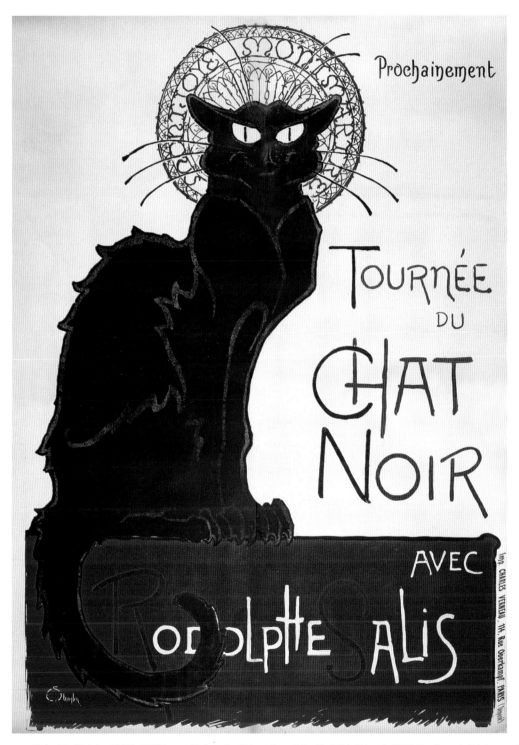

Théophile Steinlen (1859–1923)
Colour lithograph, 140 x 100 cm (55 x 39⅓ in)
• Van Gogh Museum, Amsterdam

Poster advertising a tour of the Chat Noir Cabaret, 1896 Like Grasset, Steinlen was born in Lausanne, Switzerland, but later moved to Montmartre in Paris. He was a regular at the Chat Noir nightclub, whose owner commissioned this classic poster to promote his business.

Félix Edouard Vallotton (1865–1925)
Woodblock on paper, 17.3 x 22.1 cm (6⅔ x 8¾ in)
• Private Collection

La Paresse (Laziness), 1896 Vallotton was another member of Les Nabis associated with Art Nouveau. His woodcuts featured in the opening exhibition at Bing's gallery in December 1895, followed by a solo show he enjoyed there the following year.

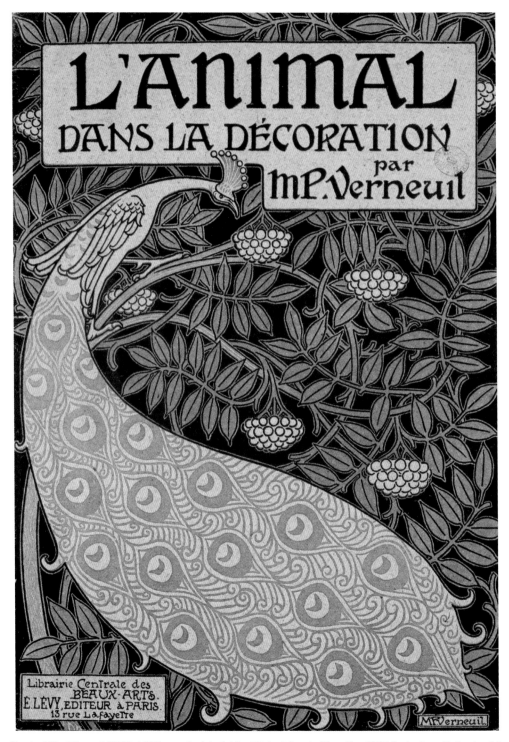

Maurice Pillard Verneuil (1869–1942)
Colour lithograph, 46.5 x 34 cm (18⅓ x 13⅓ in)
• Private Collection

Book Jacket for *L'Animal dans la Décoration*, 1897 Contrasting with the simplicity of his magazine images, Verneuil's portfolio *L'Animal dans la Décoration* was a book of elaborate patterns using animal and plant forms that could be reproduced on wallpapers, tiles and textiles.

Georges de Feure (1868–1943)
Colour lithograph, 80 x 62 cm (31⅔ x 24⅔ in)
• Private Collection

Diana, 1897 This print by the designer and graphic artist Georges de Feure first appeared in one of the 24 editions of *L'Estampe Moderne*, a monthly pamphlet of modern prints published between 1897 and 1899.

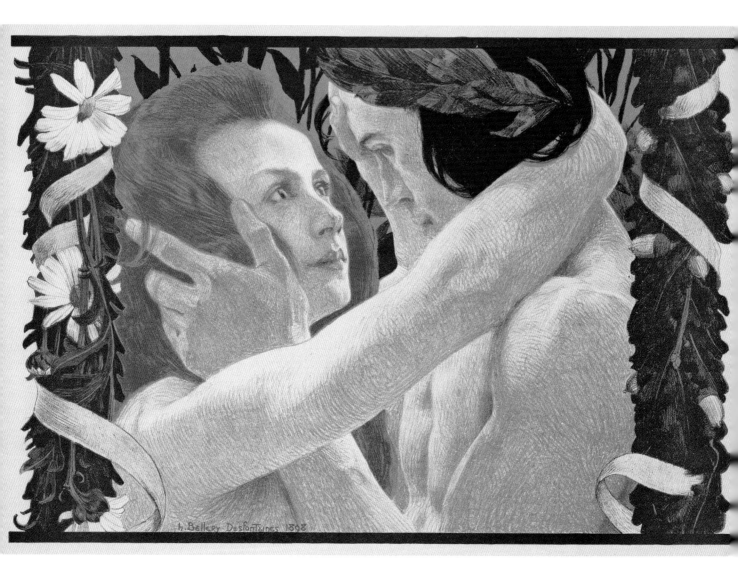

Henri-Jules-Ferdinand Bellery-Desfontaines (1867–1910)
Photolithograph, 25.6 x 38.3 cm (10 x 15 in)
• The Metropolitan Museum of Art, New York

Enigma, 1898 The intensity of the couple's mutual absorption, their evident nakedness, the surrounding Eden; the longing for nature in Art Nouveau evoked prelapsarian fantasies of escape from modernity to a simpler, more consummated life.

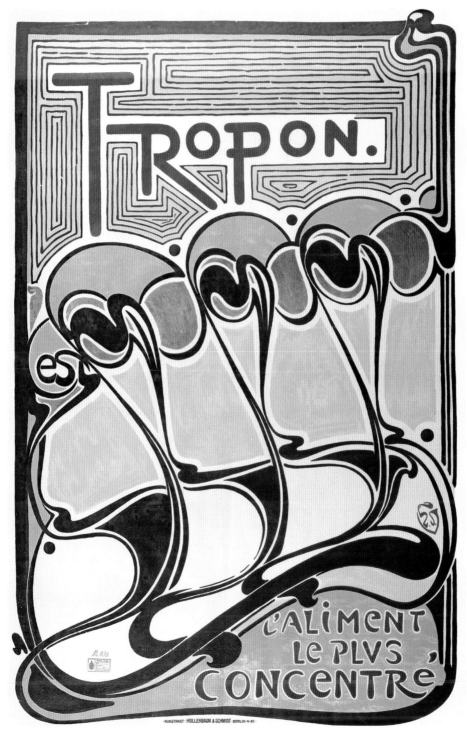

Henry van de Velde (1863–1957)
Colour lithograph, 112.4 x 75.5 cm (44¼ x 29¾ in)
• Bibliothèque des Arts Décoratifs, Paris

Tropon poster, 1898 In 1905, van de Velde established the school in Weimar, Germany that later became the Bauhaus school of modern design. As this poster demonstrates, one aspect of Art Nouveau was a tendency towards Modernist motivic abstraction.

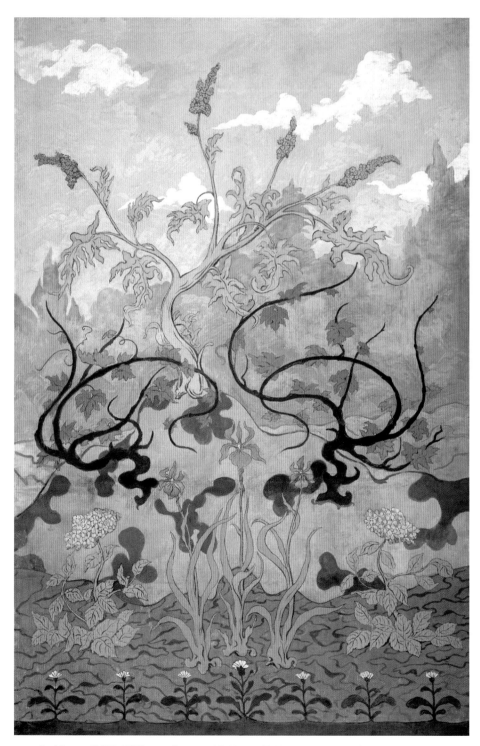

Paul Ranson (1863–1909)
Oil on canvas, 245.7 x 163.9 cm (96¾ x 64½ in)
• Private Collection

(Jaunes et Iris Mauves (Goldenrod and Mauve Irises), 1899 The decorative qualities of Ranson's art secured commissions such as this panel, one of four he produced for the dining room of a house in Sète in the South of France.

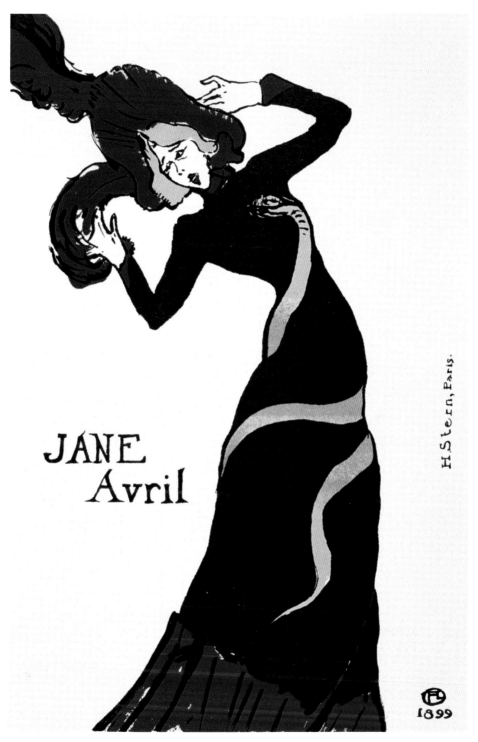

Henri de Toulouse-Lautrec (1864–1901)
Lithograph, 129.1 x 93.5 cm (50⅘ x 36⅘ in)
• State A. Pushkin Museum of Fine Arts, Moscow

Poster for French dancer, Jane Avril, 1899 Jane Avril (née Jeanne Beaudon, 1868–1943) was a celebrated can-can dancer, one of the stars of the Moulin Rouge. She was also a close friend of Toulouse-Lautrec, who depicted her in a number of posters, prints and paintings.

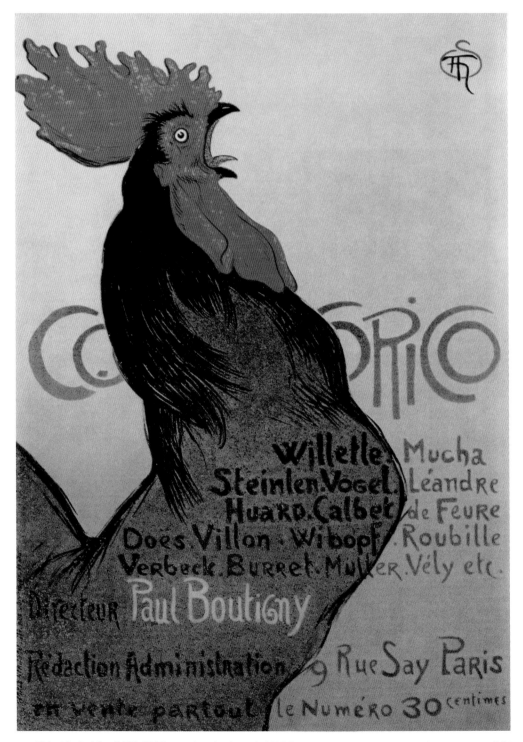

Théophile Steinlen (1859–1923)
Colour lithograph, 135 x 100 cm (53 x 39⅓ in)
• Museu Nacional d'Art de Catalunya

Cocorico (poster), 1899 The inclusion of text in Japanese prints gave a green light to Art Nouveau designers to do likewise; the combination of text and image was the perfect template for the new medium of the advertising poster.

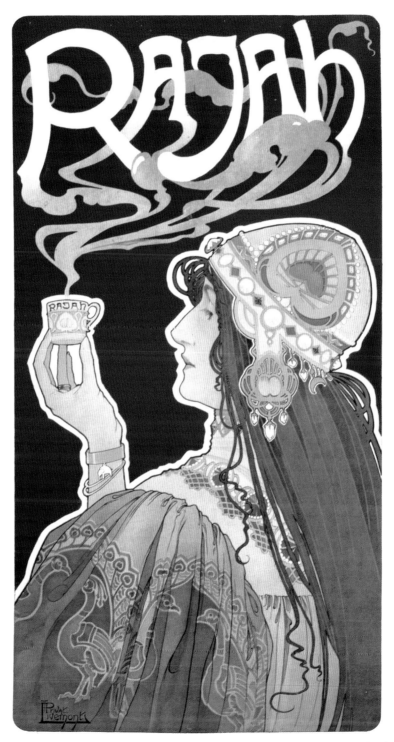

Henri Privat-Livemont (1861–1936)
Chromolithograph, 76.2 x 40.2 cm (30 x 15⅞ in)
• L'Affchiste Gallery, Montreal

Rajah Tea, poster, woman with a teacup, *c.* **1900** The simplicity of design, the clear use of colour, the sinuous line with its suggestion of desire made Art Nouveau an ideal visual style for selling consumer goods to a growing middle class susceptible to pleasure.

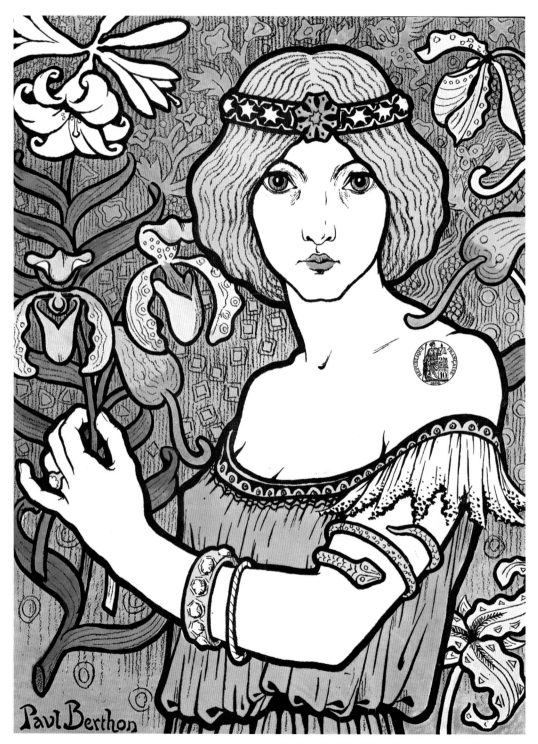

Paul Berthon (1872–1909)
Colour lithograph • Private Collection

Poster for the Salon des Cent, 1900 Aside from advertising, graphic artists in the 1890s were able to sell work through other outlets, such as the Salon des Cent, a regular Paris exhibition featuring poster art by leading practitioners in the medium.

Georges de Feure (1868–1943)
Stained-glass window, 200 x 91 cm (78¾ x 35⅘ in)
• Virginia Museum of Fine Arts

Stained-glass window depicting female figure, 1901–02 De Feure was one of the main designers commissioned by Siegfried Bing to design objects and interiors for his Paris shop, the Maison de l'Art Nouveau, where stained-glass art windows like this one were among the items on offer.

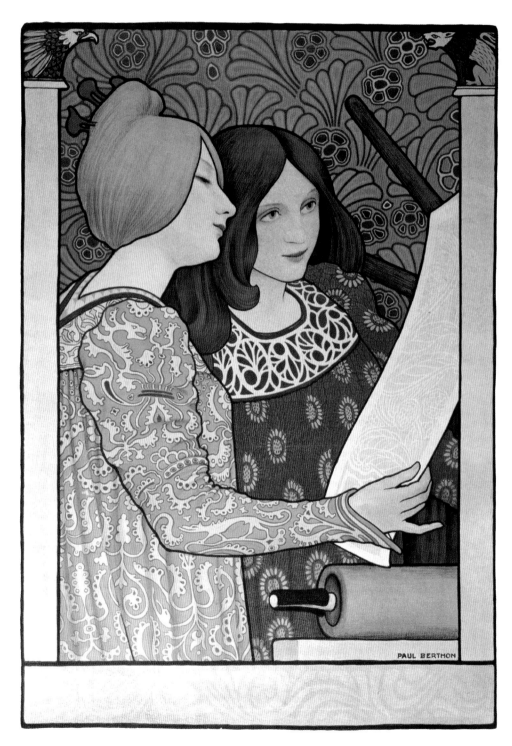

Paul Berthon (1872–1909)
Colour lithograph • Royal Albert Memorial Museum, Exeter

Untitled (Two Girls at a Printing Press), *c.* **1902** The colour range from red and orange to yellow, along with a similar variety of motifs in the women's dresses and the background wallpaper, gives this print a pleasing visual unity.

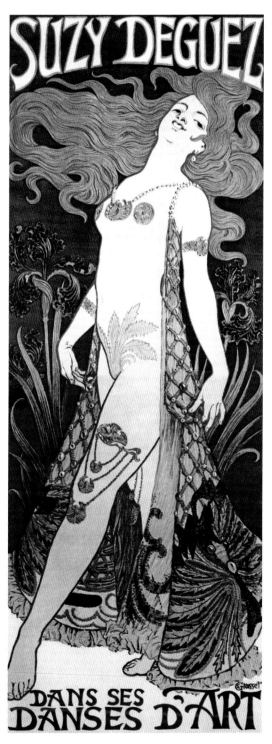

Eugène Grasset (1841–1917)
Colour lithograph, 195.6 x 75.6 cm (77 x 29¾ in)
• Private Collection

Suzy Deguez poster A rival to the notorious Mata Hari (1876–1917), Suzy Deguez was a dancer at the Folies Bergère who titillated audiences with exotic routines she is said to have danced nude. This poster deliberately exploits her sensual reputation.

Netherlands, Italy, Nordic & Eastern Europe

Art Nouveau was quickly seized upon by artists in countries which had either fallen behind or had long been peripheral to the main developments in European art. It held the promise of a fresh start.

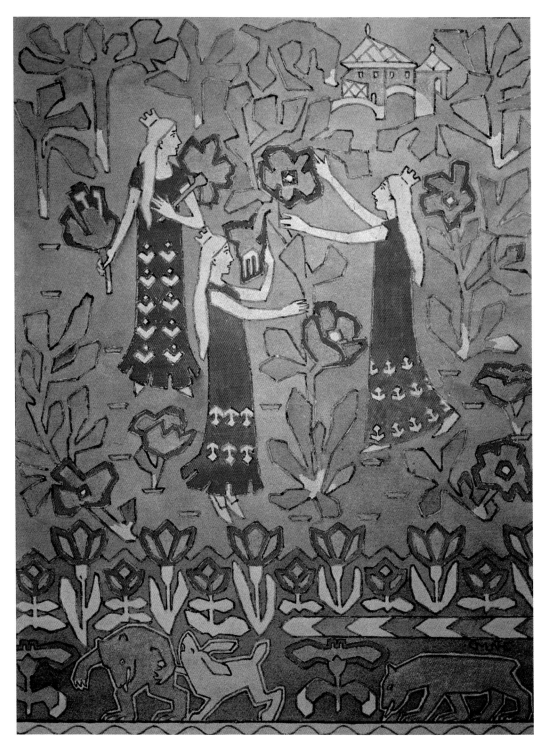

Gerhard Munthe (1849–1929)
Brush, watercolour, gouache, over graphite and coloured pencil
on paper, 76 x 57.5 cm (30 x 22⅔ in) • Nasjonalmuseet, Oslo

Tre prinsesser Eventyrhaven (Three Princesses in the Fairytale Garden), 1892 A Norwegian artist,
Munthe developed a distinctive graphic style, called the Viking or Dragon style, inspired by the ancient Viking
longships discovered towards the end of the nineteenth century through archaeological digs in Norway.

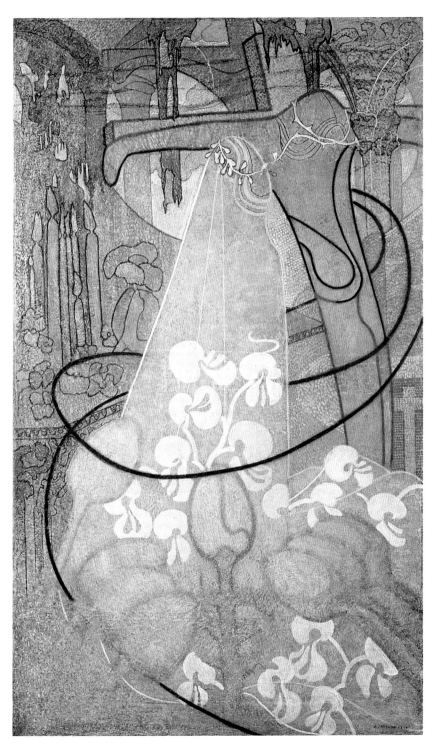

Jan (Johann) Thorn Prikker (1868–1932)
Oil on canvas, 146.05 x 88.2 cm (57½ x 34¾ in)
• Rijksmuseum Kröller-Müller, Otterlo

Bride of Christ, 1892–93 The level of decoration in this marvellous painting is so complex, the use of line so mysterious, that even the apparent content is hard to fathom, let alone its meaning.

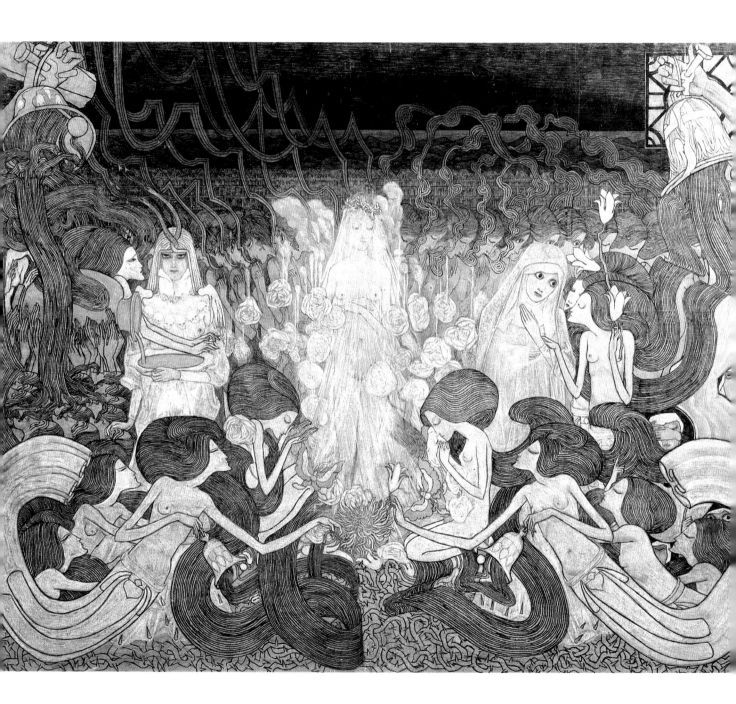

Jan Toorop (1858–1928)
Chalk, pencil and charcoal on paper, 78 x 98 cm (30¾ x 38½ in)
• Rijksmuseum Kröller-Müller, Otterlo

The Three Brides, 1892–93 Toorop's upbringing in Indonesia instilled in him a deep understanding of the art of that region, especially the Javanese *Wayang* shadow puppets from whom the semi-naked spirit women in this painting appear to be derived.

Jan Toorop (1858–1928)
Poster, 92.7 x 61.9 cm (36½ x 24⅜ in)
• Bibliothèque des Arts Décoratifs, Paris

Delftsche Slaolie, advertising poster for salad dressing, 1895 Toorop explored all the aesthetic resources of his era, never settling on a single definitive style. This advertising poster, one of several he made – and apparently promoting a salad dressing – shows his superlative handling of line.

Elena Dimitrevna Polenova (1850–98)
Oil on canvas, 144 x 103 cm (56¾ x 40½ in)
• Abramtsevo State Museum, near Moscow

Girl with Dragon, 1895 From the early 1880s, Polenova lived for years at the Abramtsevo Artists' Colony near Moscow. Drawing on Russian folklore, this beautifully coloured painting features heavily stylized flora, offering a Russian twist on the Art Nouveau style.

Akseli Gallen-Kallela (1865–1931)
Tempera on canvas, 122 x 125 cm (48⅓ x 49¼ in)
• Turku Art Museum

The Defence of the Sampo, 1896 Gallen-Kallela's paintings based on the *Kalevala*, the national epic poem, are his most important works. This image was seen by Finns as an allegory for the fight to win back the soul of Finland from Russian rule.

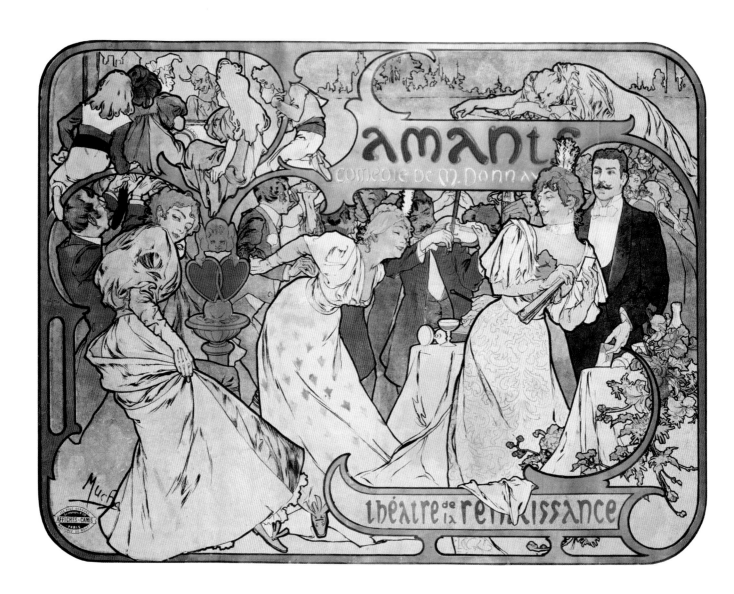

Alphonse Mucha (1860–1939)
Colour lithograph, 104 x 138 cm (41 x 54⅓ in)
• Private Collection

Poster advertising 'Amants', a comedy at the Théâtre de la Renaissance, 1896 A trained painter, Mucha made his name through the posters he produced for Sarah Bernhardt and the Théâtre de la Renaissance in Paris. This one, unusually in landscape format, reveals his mastery of composition.

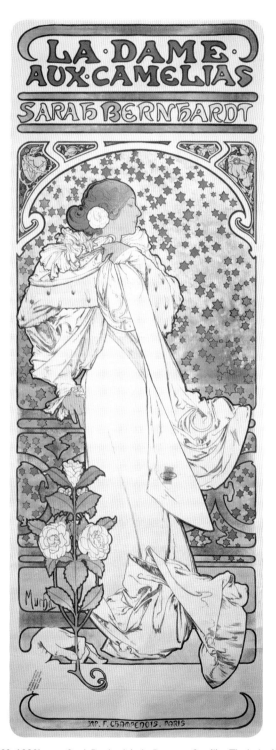

Alphonse Mucha (1860–1939)
Colour lithograph, 207.3 x 76.2 cm (81⅔ x 30 in)
• Library of Congress, Washington, D.C.

Sarah Bernhardt in *La Dame aux Camélias (The Lady of the Camellias)*, **play by Alexandre Dumas, 1896**
Sarah Bernhardt was the most dynamic actress of her generation, celebrated above all for her voice;
Marguerite Gautier in Dumas' play was her most famous role. Mucha's vertical-format posters for
Bernhardt's productions revolutionized poster design.

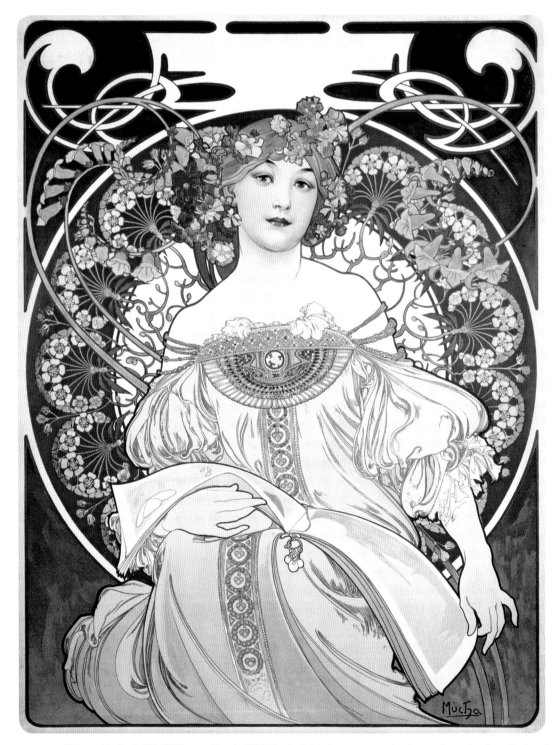

Alphonse Mucha (1860–1939)
Colour lithograph, 104 x 138 cm (41 x 54⅓ in)
• Private Collection

Reverie, 1897 The fresh-faced young woman, her loose and revealing dress, the Arcadian flowers in her hair and even the circular floral surround are all basic elements of a typical Mucha poster.

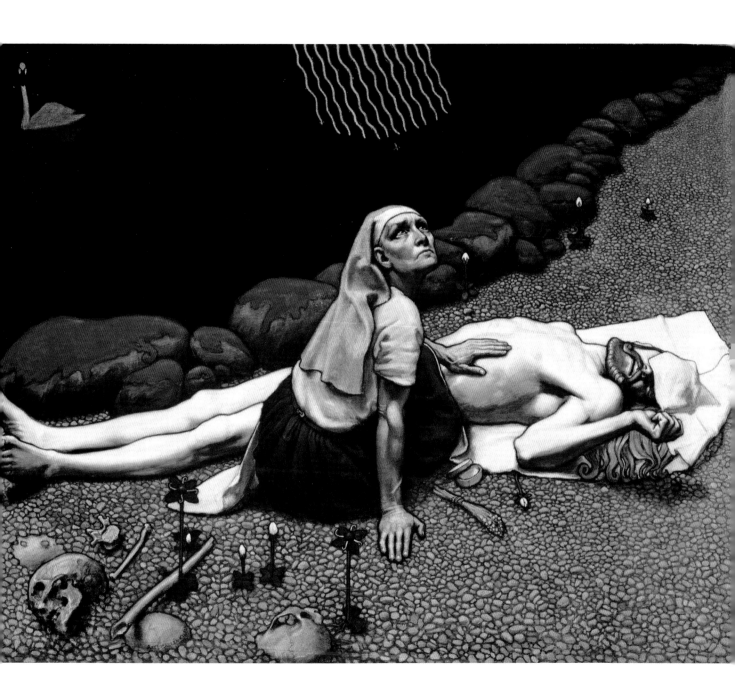

Akseli Gallen-Kallela (1865–1931)
Tempera on canvas, 85.5 x 108.5 cm (33⅔ x 42¾ in)
• Ateneum Art Museum, Helsinki

Lemminkäinen's Mother, 1897 Gallen-Kallela's *Kalevala* paintings are classics of National Romanticism, the Nordic version of Art Nouveau. The stylized depiction of stones, flowers and bodies in this painting enhances the sense of a mythic world outside historical time.

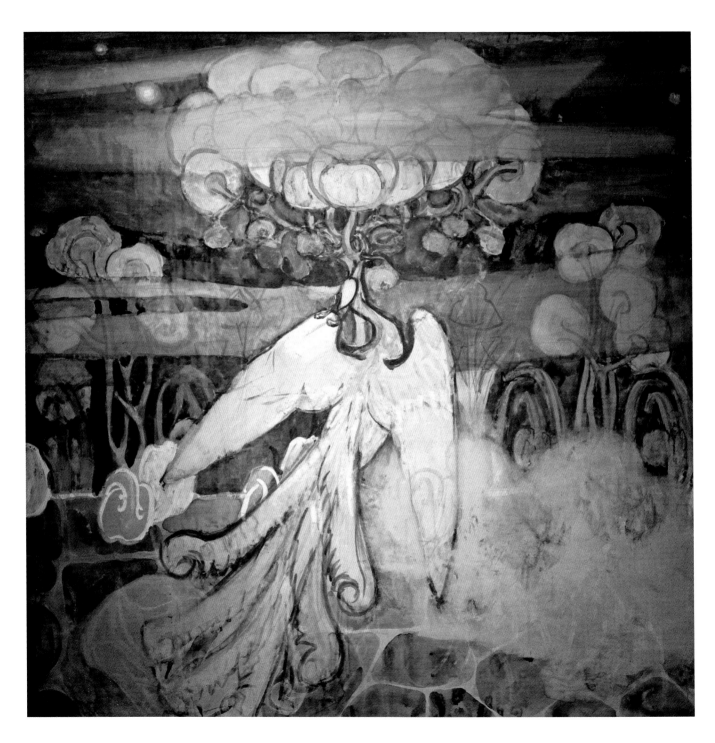

Elena Dmitrievna Polenova (1850–1898)
Gouache, bronze colour pencil on paper, 105.8 x 106 cm
(41⅔ x 41¾ in) • Tretyakov Gallery, Moscow

Firebird, 1897–98 This gouache, completed not long before the artist's death, depicts the magical Firebird of Russian legend. By this point, Polenova's work was exerting a decisive influence on a younger generation of Russian illustrators, including Ivan Bilibin.

Adolfo Hohenstein (1854–1928)
Colour lithograph, 120 x 65 cm (47¼ x 25⅗ in)
• Private Collection

Cover of Score and Libretto of the Opera *Iris*, 1898 Born in St Petersburg to German parents, Hohenstein moved as a young man to Italy, where he worked for the publisher Ricordi, producing illustrations for scores and posters for La Scala, the famous Milan opera house.

József Rippl-Rónai (1861–1927)
Tapestry, woven by the artist's wife, Lazarine Boudrion, 230 x 125 cm
(90½ x 49¼ in) • Museum of Fine Arts, Budapest

Dame en robe rouge (Lady in red dress), 1898 Another member of Les Nabis, who also produced decorative works for Bing's Maison de l'Art Nouveau, Rippl-Rónai brought the new style back to his native Hungary when he returned there in the late 1890s.

Alphonse Mucha (1860–1939)
Colour lithograph, 60 x 38 cm (23⅔ x 15 in) • Mucha Trust

The Arts: Dance, 1898 The vivacity of this print, one of a series of four, is expressed through the model's lissom pose but above all in the flamboyant motion of her dress, train and hair, infusing the image with a sense of joyful abandon.

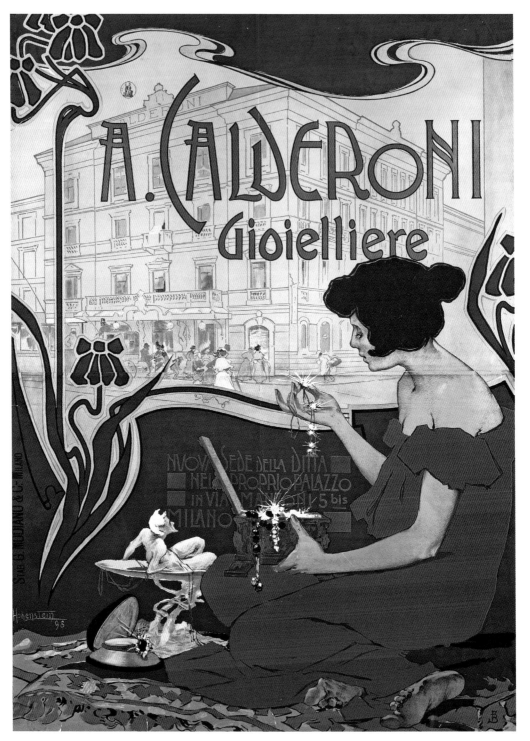

Adolfo Hohenstein (1854–1928)
Colour lithograph poster, 164.2 x 96.6 cm (64⅛ x 38 in)
• Museu Nacional d'Art de Catalunya

Advertising poster for Calderoni Jewellers in Milan, 1898 Hohenstein was one of the masters of the Art Nouveau advertising poster. The style was known in Italy as 'Stile Liberty' after the London store, whose textiles were popular in the country.

Galileo Chini (1873–1956)
Watercolour, Indian ink and pencil on paper
• Private Collection

Female profile, a sketch for the decoration of a vase, 1899 Chini was a potter, painter and designer who made sets for operas such as *Turandot* (1926) by Giacomo Puccini (1858–1924), Italy's leading composer of the early twentieth century. This image was intended for one of Chini's vases.

Ettore De Maria Bergler (1850–1938)
Fresco • Grand Hotel Villa Igiea, Palermo

Profumo del mattino (Scent of the Morning), 1899–90 This image represents a tiny section of an important work of the Stile Liberty: a vast mural painted by De Maria Bergler for the restoration of the Villa Igiea in the Sicilian capital, Palermo.

Ephraim Moses Lilien (1874–1925) **Illustration for the poem 'Isaiah the prophet', 1900** Lilien was a Jew from the region of Galicia, then part of Austria-Hungary, now western Ukraine. An early adherent of Zionism, he brought the Art Nouveau style to Jewish religious subjects.

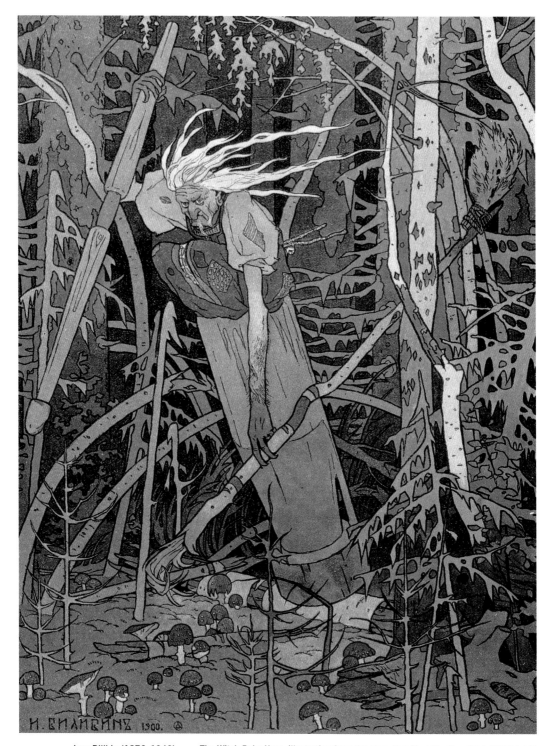

Ivan Bilibin (1876–1942)
Watercolour and ink on paper, 22.5 x 15 cm (8⅓ x 6 in)
• Private Collection

The Witch Baba Yaga, illustration from the story *Vassilissa the Beautiful*, 1902 Art Nouveau coincided with a golden age of book illustration, nowhere more so than in Russia. In folktales, Bilibin found an endlessly rich source of subjects, such as the evil spirit in this brilliantly coloured image.

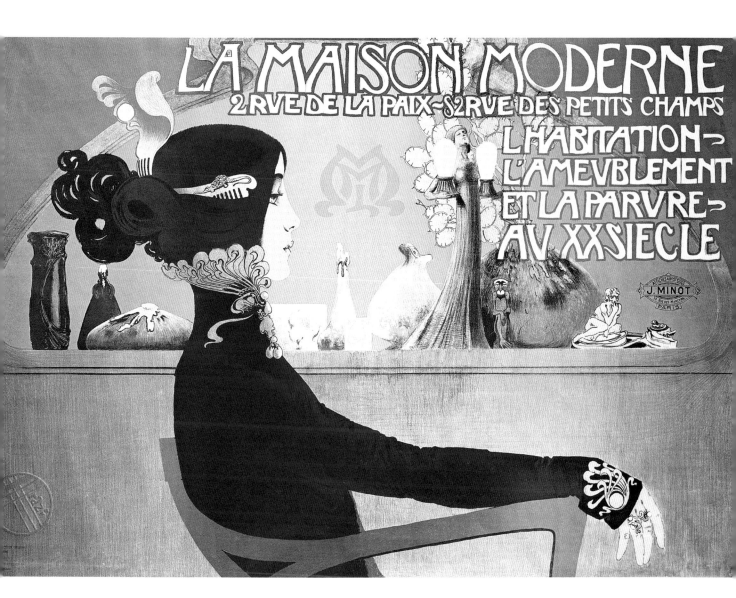

Manuel Orazi (1860–1934)
Poster, 86 x 119 cm (33⅓ x 46⅓ in)
• Bibliothèque municipale de Lyon

La Maison Moderne, *c.* 1902 Orazi was an illustrator of novels and other books, but also a poster artist, in this case for La Maison Moderne, the other important outlet for Art Nouveau in Belle Époque Paris, along with Bing's Maison de l'Art Nouveau.

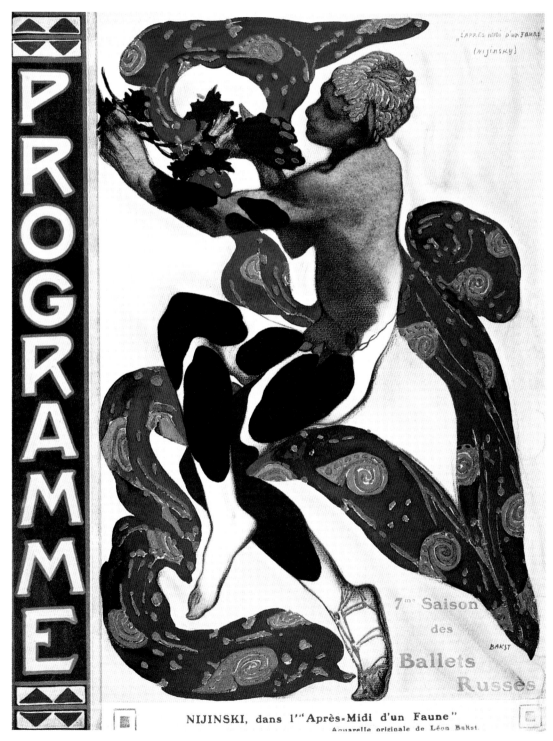

Léon Bakst (1866–1924)
Watercolour, 39.8 x 27.1 cm (15⅔ x 10⅔ in)
• Wadsworth Atheneum Museum of Art, Hartford, Connecticut

Programme cover for *L'après-midi d'un faune* **by Claude Debussy, 1912** Les Ballets Russes took Paris by storm from 1909, notoriously so with Vaslav Nijinsky's (1889–1950) *L'après-midi d'un faune*, for which Bakst designed the sets and this famous programme cover.

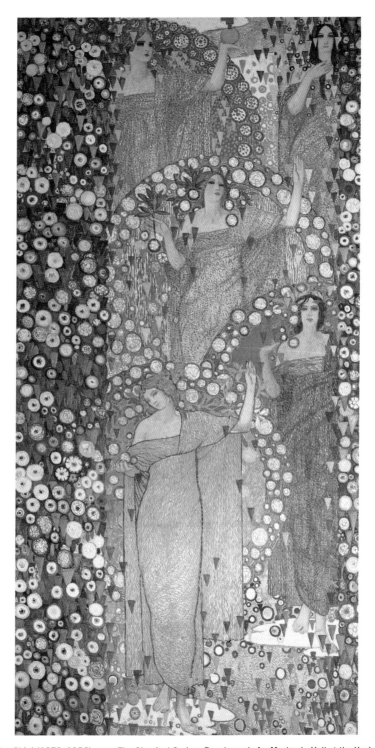

Galileo Chini (1873–1956)
Tempera, oil, stucco and gold on canvas, 390 x 330 cm
(153½ x 130 in) • Private Collection

The Classical Spring, Panels made for Mestrovic Hall at the Venice Biennale, Italy, 1914 This late work of Art Nouveau luxuriates in floral decoration reminiscent of Gustav Klimt. In fact, Chini had learnt his trade restoring the frescoes of Florentine churches and in palaces all over Tuscany.

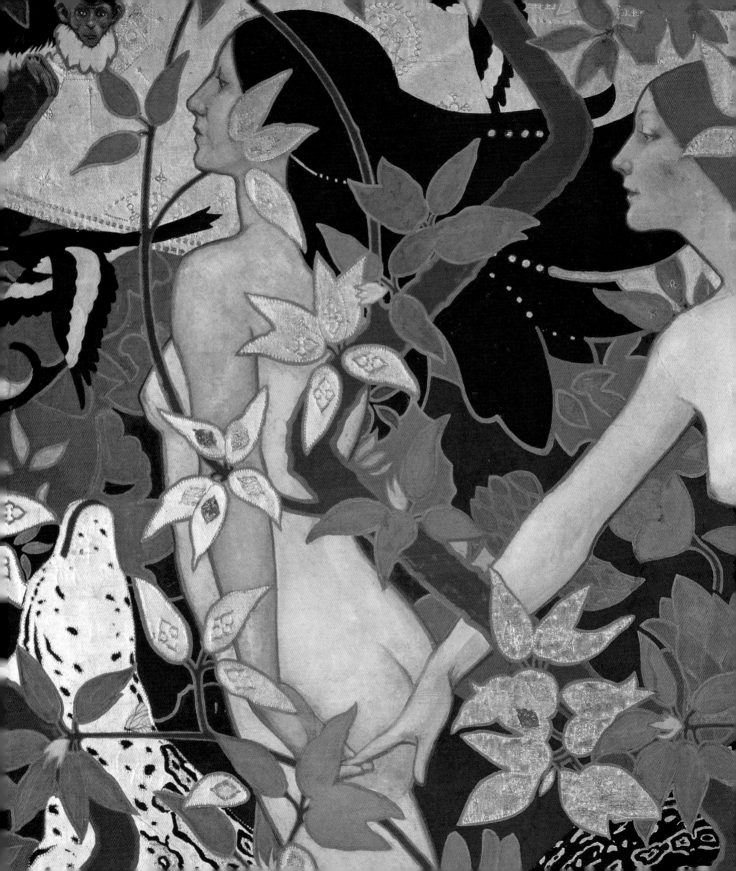

Britain & the US

Through the Arts and Crafts Movement, British art exerted a decisive influence on the development of Art Nouveau. However, in the English-speaking countries, the style itself was only a serious force in Scotland and America.

Arthur Heygate Mackmurdo (1851–1942)
Woodcut, 30.48 x 22.86 cm (12 x 9 in)
• Victoria and Albert Museum, London

Title page to *Wren's City Churches*, 1883 English designers were suspicious of Continental Art Nouveau, but the feeling was far from mutual. Mackmurdo's swirling design was an early inspiration for Art Nouveau designers who admired the Arts and Crafts style.

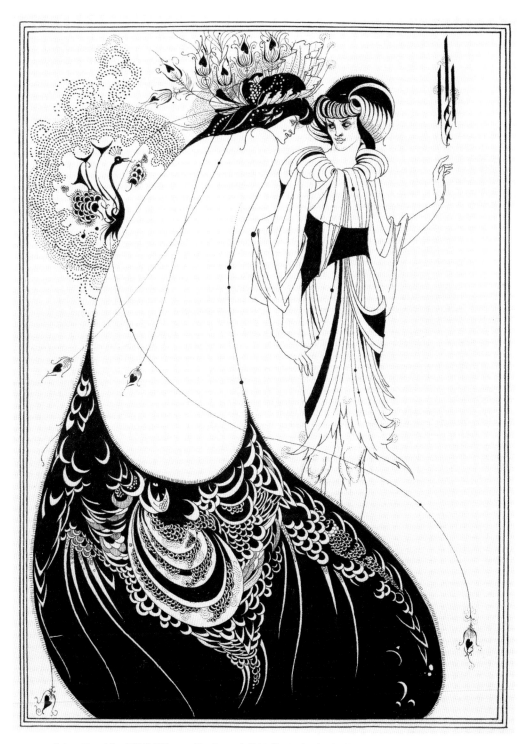

Aubrey Beardsley (1872–98)
Black ink and graphite on paper, 22.7 x 16 cm (9 x 6⅓ in)
• Fogg Art Museum, Harvard Art Museums, Boston, Massachusetts

The Peacock Skirt, illustration for the English edition of *Salome* by Oscar Wilde (1854–1900), 1893
The peacock was an exotic motif beloved of both Art Nouveau and the Aesthetic movement from which Aubrey Beardsley emerged. His illustrations for Wilde's *Salome* were instrumental in the development of Continental Art Nouveau.

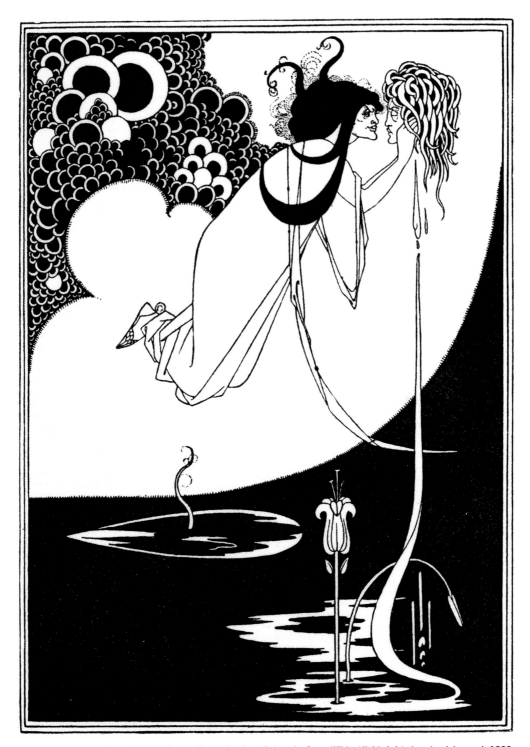

Aubrey Beardsley (1872–98)
Line block print, • Museo Teatrale alla Scala, Milan

Illustration from *Salome* by Oscar Wilde: 'J'ai baisé ta bouche, Iokanaan', 1893
Beardsley's shocking print reflects the sensational plot of Wilde's play. An e*nfant terrible* who died before he could grow up, in 1896 he also produced a series of pornographic illustrations for an edition of Aristophanes's play *Lysistrata*.

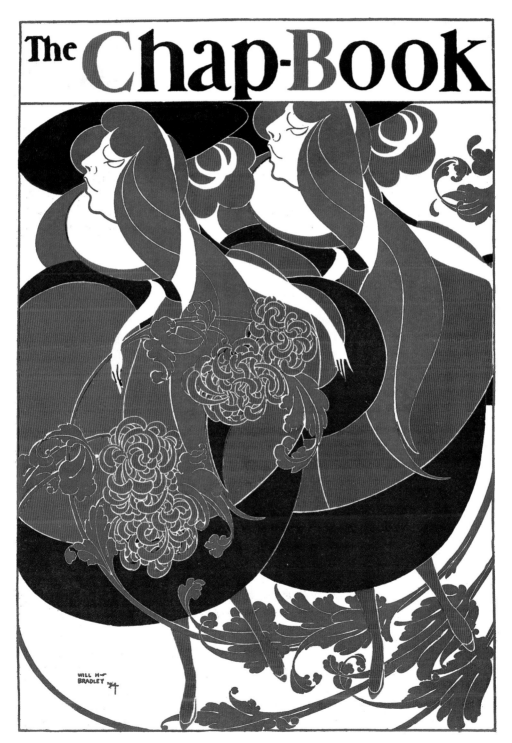

William H. Bradley (1868–1962)
Colour lithograph, Image: 48.3 x 33.02 cm (19 x 13 in)
Sheet: 50.8 x 35.56 cm (20 x 14 in)
• The Metropolitan Museum of Art, New York

Poster for *The Chap-Book*, **1894** Bradley was the father of the American Art Nouveau
poster. In this typically stylized image, the ostensible subject is subservient to the decorative
values of line, colour and pattern.

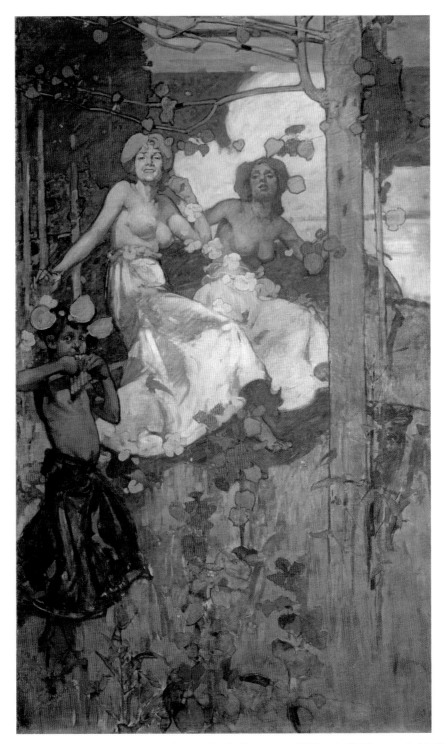

Frank Brangwyn (1867–1956)
Oil on canvas, 255 x 155 cm (100⅓ x 61 in)
• Private Collection

Dancing (a design for the entrance of Maison de l'Art Nouveau, Paris), 1895 A Belgian-born Anglo-Welsh artist, and a brilliant colourist, Brangwyn was famous above all for his murals. This virtuoso painting was one of a pair he made for the entrance of Bing's gallery at its opening in December 1895.

Charles Rennie Mackintosh (1868–1928)
Pencil and watercolour on paper, 32 x 25 cm
(12½ x 9⅘ in) • Glasgow School of Art

The Tree of Personal Effort, 1895 This delicate watercolour displays many of the main components of Mackintosh's style: the vertical columns, the mirror symmetry, the central circle and the subtle tracery learned from Celtic art.

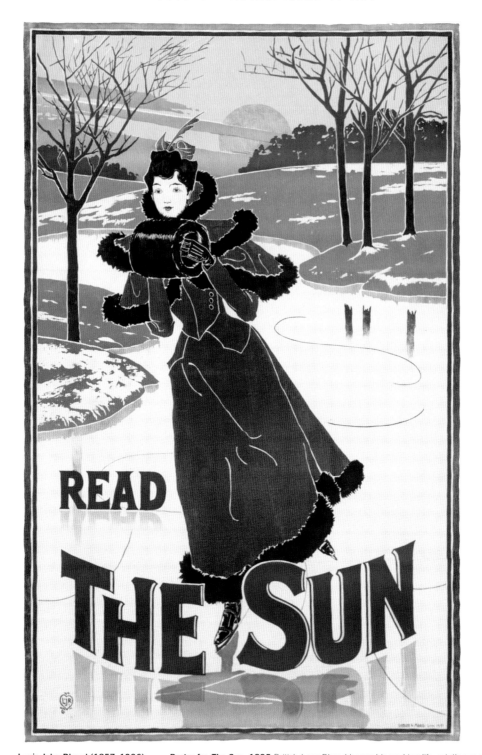

Louis John Rhead (1857–1926)
Lithograph, 118.9 x 73.7 cm (46⅓ x 29 in)
• The Metropolitan Museum of Art, New York

Poster for *The Sun*, 1895 British-born Rhead began his working life painting ceramics in the Potteries in England, but at the age of 24 he emigrated to America, where he worked as a poster artist for famous magazines like *Harper's Bazaar*.

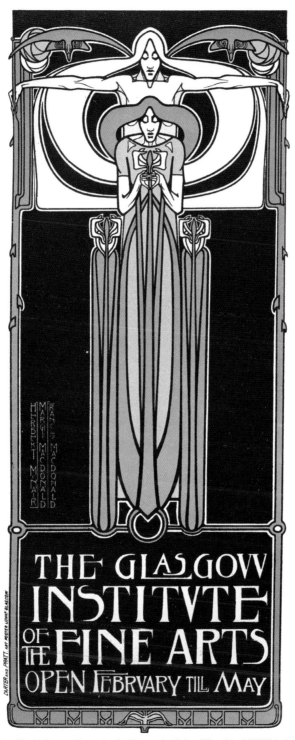

Frances MacDonald (1873–1921), Herbert MacNair (1868–1955) and Margaret MacDonald (1864–1933)
Colour lithograph, 251.5 x 117.8 cm (99 x 46⅓ in)
• Glasgow Museums Resource Centre

Poster for the Glasgow Institute of Fine Arts, 1897 This classic poster by married couple Frances MacDonald and Herbert MacNair, and Frances's sister Margaret, displays all the most distinctive qualities of the Glasgow School: rectilinear format, mirror symmetry, gaunt but noble figures and the characteristic rose ball motifs.

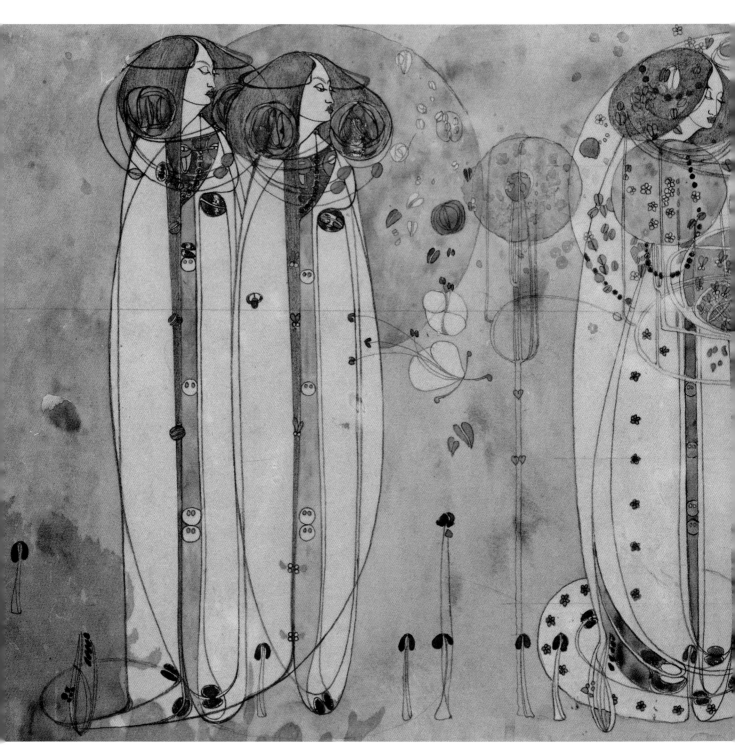

**Charles Rennie Mackintosh (1868–1928)
and Margaret MacDonald Mackintosh (1865–1933)**
Watercolour and pencil on paper, 32.9 x 69.3 cm (13 x 27¼ in)
• Private Collection

The Wassail, 1900 This watercolour was the basis of a panel decoration by Mackintosh and MacDonald for the interior of Miss Cranston's Tearooms on Ingram Street in Glasgow, one of four such establishments in the city whose environments they transformed.

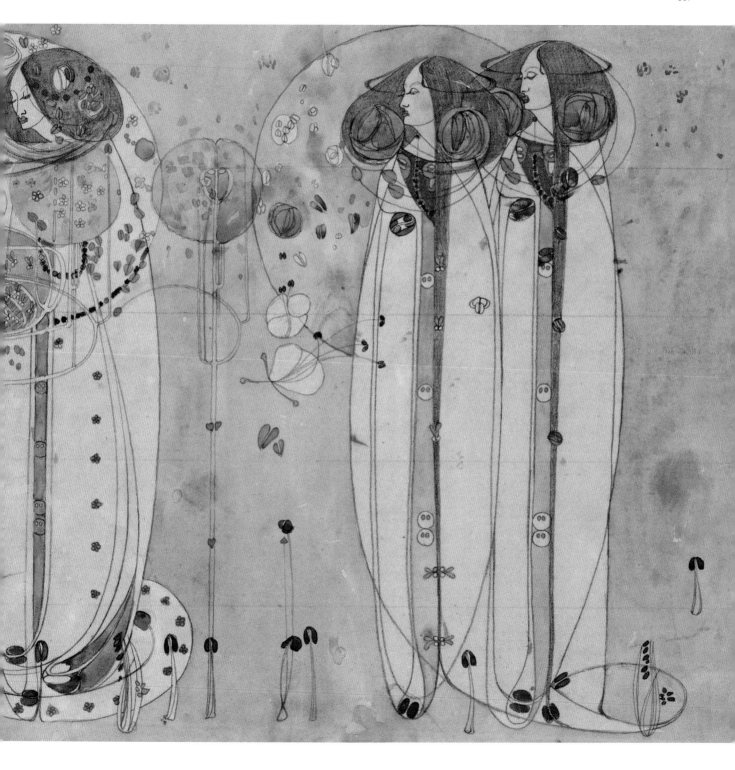

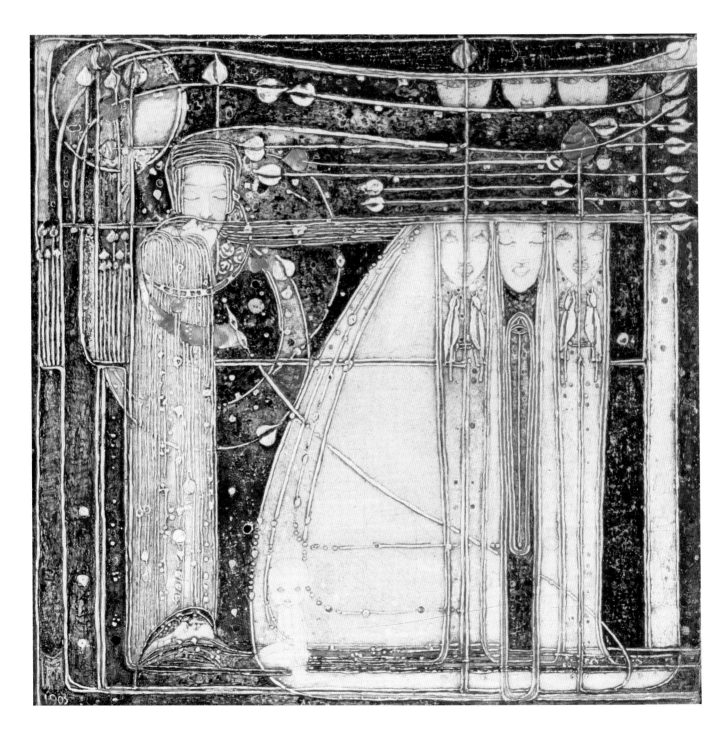

Margaret MacDonald Mackintosh (1865–1933)
Inlaid gesso panel, 20 x 20 cm (7⅘ x 7⅘ in) • Private Collection

The Opera of the Wind, *c.* **1902** MacDonald made this panel and two others for the music room of the residence of Fritz Wärndorfer (1868–1939), the Viennese mill owner, patron and financier of the Wiener Werkstätte.

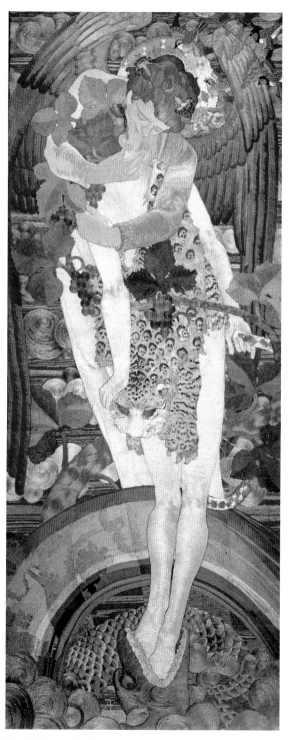

Phoebe Anna Traquair (1852–1936)
Silk and gold thread embroidered on linen, 188.2 x 74.2 cm
(75 x 29¼ in) • Scottish National Gallery, Edinburgh

The Progress of a Soul: The Victory, 1902 Irish-born Traquair was a member of the Arts and Crafts Movement in Scotland, but this magnificent work, the final image in a quadriptych called *The Progress of a Soul*, has all the decorative qualities of Art Nouveau.

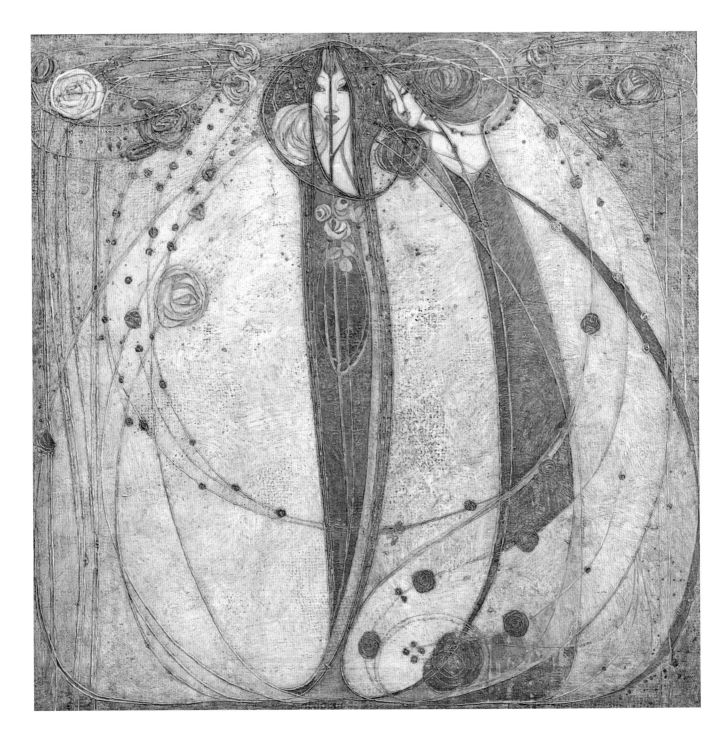

Margaret MacDonald Mackintosh (1865–1933)
Painted gesso over hessian with glass beads, 97.8 x 100.3 cm
(38½ x 39⅔ in) • Private Collection

The White Rose and the Red Rose, 1902 MacDonald collaborated with her husband Charles
Rennie Mackintosh on a number of interiors in Glasgow and also with her sister Frances on highly
original repousséd panels. This work is characteristically daring in its use of materials.

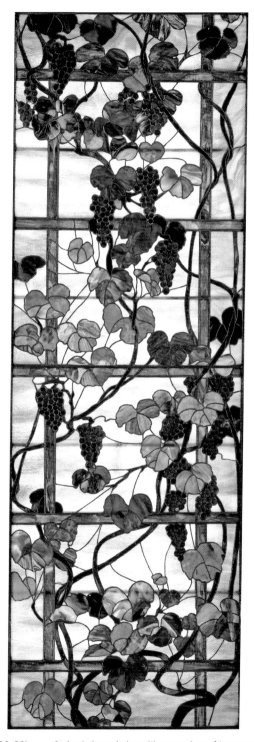

Tiffany Studios (1902–32)
Leaded Favrile glass, 248.9 x 91.4 cm (98 x 36 in)
• The Metropolitan Museum of Art, New York

Stained-glass window with grapes (one of two panels), *c.* **1902–15** Tiffany trained as a painter, but switched to glass art in his late twenties. Favouring opalescent glass, he started to make it himself after being unable to convince glassmakers to leave in the impurities he prized.

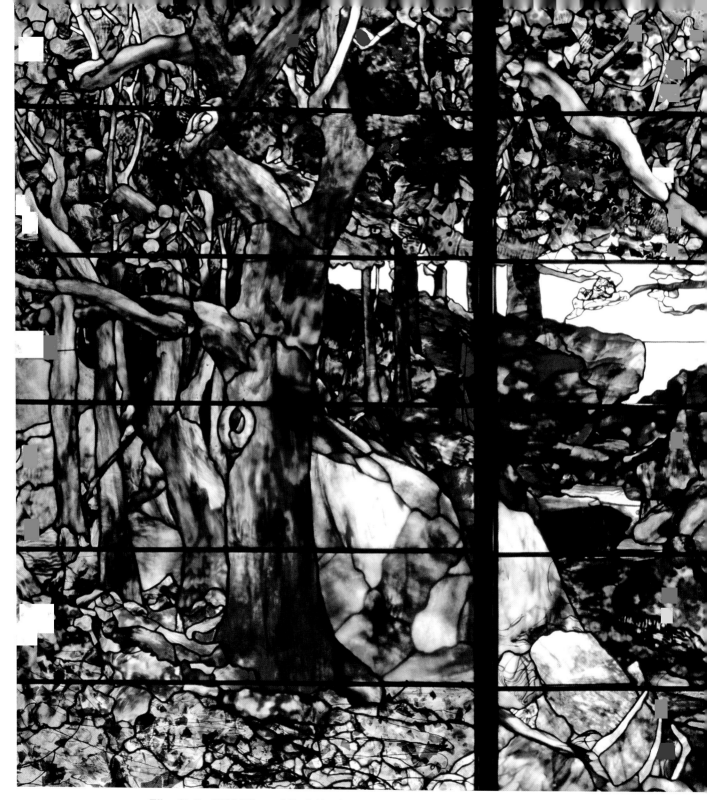

Tiffany Studios (1902–32)
Glass, copper foil, lead and wood, 219.7 x 334.2 cm
(86⅔ x 131⅔ in) • Museum of Fine Arts, Houston, Texas

A Wooded Landscape in Three Panels, *c.* **1905** After years of experiments, Tiffany patented a new type of glass he called *Favrile*, whose iridescence is integral to the material, causing gradations of tone that lend landscapes like this one the subtlety of an oil painting.

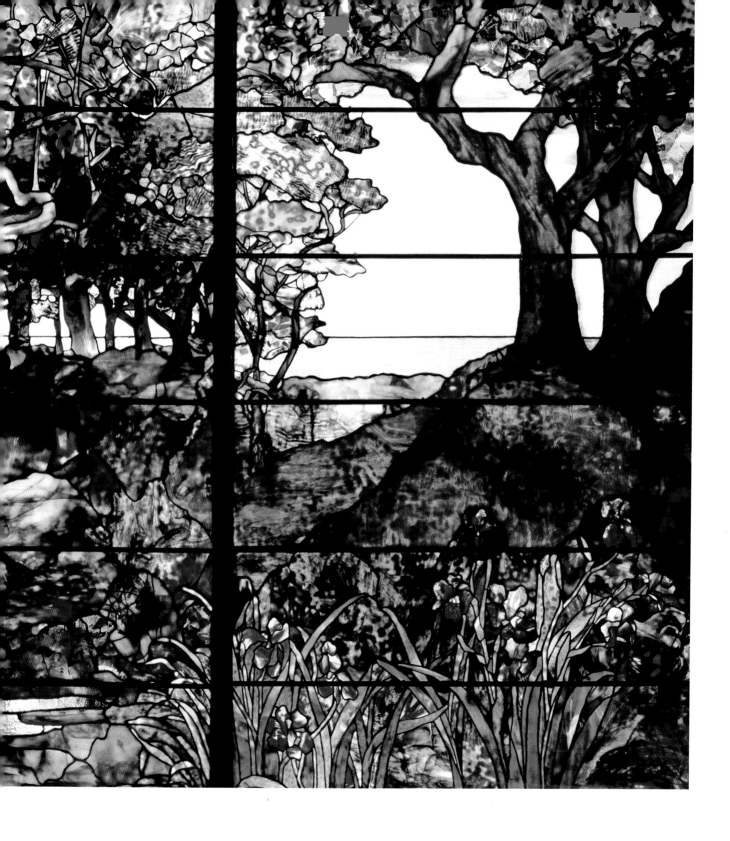

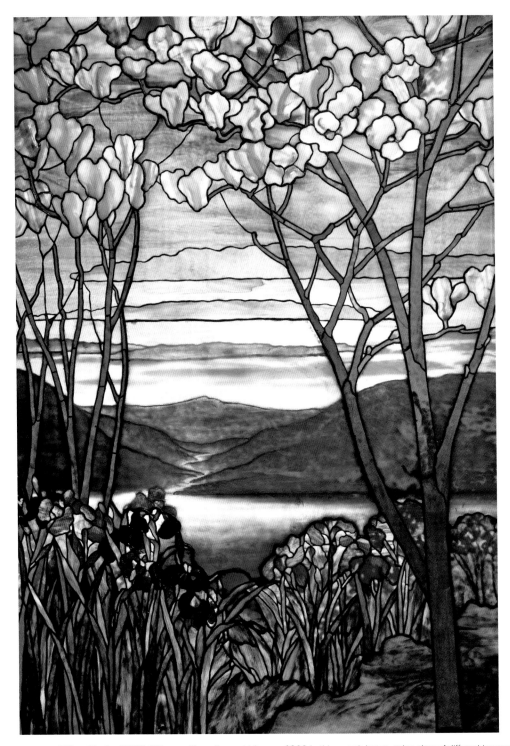

Tiffany Studios (1902–32)
Leaded Favrile glass, 153 x 106.7 cm (60¼ x 42 in)
• The Metropolitan Museum of Art, New York

Magnolias and Irises, *c.* 1908 In this superb image, using glass of different transparencies Tiffany created foreground and background, and even spatial recession, in a way that no one before him had managed in the medium of stained glass.

Robert Burns (1869–1941)
Oil or tempera and gold leaf on canvas,
198.1 x 198.1 cm (78 x 78 in) • National Galleries of Scotland

The Hunt (previously known as Diana and Her Nymphs), *c.* **1926** Burns's stylized early illustration
Natura Naturans (1891) anticipated Art Nouveau. In the mid-1920s, long after the style had faded, he
produced this decorative masterpiece for another Scottish tearoom, Crawford's in Edinburgh.

Indexes

Index of Works

Page numbers in *italics* indicate illustration captions.

General Index

Masterpieces of Art
FLAME TREE PUBLISHING

A new series of carefully curated print and digital books covering the world's greatest art, artists and art movements.

If you enjoyed this book please sign up for updates, information and offers on further titles in this series at

blog.flametreepublishing.com/art-of-fine-gifts/